IMAGES
of America

PALM HAVEN

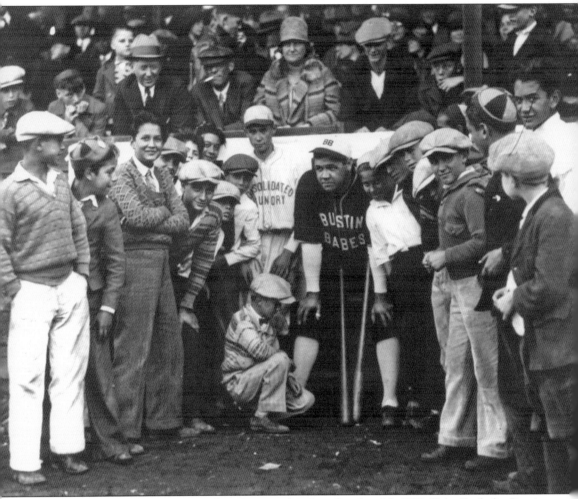

SODALITY PARK, SAN JOSE. In this photograph taken October 26, 1927, Babe Ruth (in Bustin Babes uniform) poses with youngsters eager to see him, Lou Gehrig, and "Lefty" O'Doul play an exhibition game at San Jose's Sodality Park. The local clubs—Kelley's All Stars and the Consolidated Laundry—would play. The *San Jose Mercury & Herald* organized the event and instructed fans to take the Palm Haven trolley car from Market Street to Sodality Park. The proceeds from the game were to benefit the Home of Benevolence. Lydia McKee, the home's highly regarded leader for 28 years, died in her home at 704 Palm Haven Avenue just over four years after this game. She is believed to be in the background of this image, standing above the Consolidated Laundry player. (Courtesy of History San Jose.)

ON THE COVER: The Consolidated Laundry Company was a major San Jose employer for many years. Founder Stephen Saunders, a Palm Haven resident at 995 Clintonia Avenue, held principal ownership in the company and can be seen standing second from left in a dark, three-piece suit. His company sponsored the local minor-league baseball club under its name. (Courtesy of History San Jose.)

IMAGES
of America

PALM HAVEN

Michael Borbely and Brian Hoffman

ARCADIA
PUBLISHING

Published by Arcadia Publishing
Charleston, South Carolina

Printed in the United States of America

Library of Congress Control Number: 2013934158

For all general information, please contact Arcadia Publishing:
Telephone 843-853-2070
Fax 843-853-0044
E-mail sales@arcadiapublishing.com
For customer service and orders:
Toll-Free 1-888-313-2665

Visit us on the Internet at www.arcadiapublishing.com

CONTENTS

ACKNOWLEDGMENTS

So many people over the past century can take credit for making this book possible. These range from the early Palm Haven residents, who fought to preserve the area for future generations, to the Palm Haven Restoration Committee of the last 10 years, which has worked to restore, preserve, and rehabilitate Palm Haven's historic streetscape through its organized homes tours and community events. All of these efforts have laid the foundation for the development of this book.

I owe a special thanks to Brian Hoffman, who has brought a passion and drive for the fascinating history of Palm Haven. His positive energy and penchant for solving mysteries helped untangle so many family stories.

The team at History San Jose is a big part of the success in producing this book. James Reed and his crew made themselves available to me for countless hours as I scoured for data from the most unusual points of origin in hopes of finding a hidden gem. The city owes much praise to volunteer Nadine Nelson for giving so much of her time to History San Jose. Her steadfast dedication is behind the successful use of History San Jose photographs on many of these pages. I am personally thankful to Nadine for her time spent with me.

I also want to thank Anne Louise Heigho, the volunteer music specialist at History San Jose since 1987. Her collected information about how important San Jose's music scene was at the turn of the 20th century lent a marvelous dimension to my research. Thanks go to donors of family histories, including Carolyn Allen, Norvelle Benevento, Barbara Bohnett, Gabriela D'Arrigo, Brad Fanta, Mariellen Klein, Nancy O'Sullivan, Anne Reiss, Elizabeth Eriksson Sweder, Peter Wolfe, and so many more. And finally, many thanks go to my production editor, Tim Sumerel, and to my acquisitions editor, Jared Nelson, for all his support and encouragement to the end.

Unless otherwise noted, all images appear courtesy of History San Jose.

INTRODUCTION

Next to the right of liberty, the right of property is the most important
individual right guaranteed by the Constitution and the one which,
united with that of personal liberty, has contributed more to the growth of
civilization than any other institution established by the human race.

—William Howard Taft,
27th American president

It was upon this mighty declaration by outgoing US president William Howard Taft in 1913 that a three-way partnership was formed in San Jose, California, between Alfred Clifton Eaton, Ashley Clinton Vestal, and Thomas Henry Herschbach. Eaton, Vestal & Herschbach (EV&H) purchased a swath of property from the estate of Sylvester Newhall at the southern edge of the city of San Jose and built what Mayor Thomas Monahan hailed as a masterpiece. "Palm Haven is destined to occupy a proud position among the well-known residence parks of California" was the developers' claim.

The residence-park concept of planned neighborhoods with restrictive covenants was relatively new in the United States at the turn of the 20th century but became wildly popular by 1913. Developers embraced elements of the City Beautiful and Garden City movements by laying out curving streets embellished with planned landscaping and architectural features such as entrance pillars, sculpture, and indoor and outdoor community-gathering areas. Deeds came with restrictions on development and property uses, intended to preserve the design and prohibit properties from being used in commercial activities or other nonresidential ways. "No store, saloon, grocery, or mercantile business shall be carried on, nor any spirituous or malt liquors manufactured, sold, exchanged, bartered, or dealt," reads the clause on every Palm Haven property deed from this time period.

Like many pre–World War I residence parks, Palm Haven was located on the local trolley line, the Peninsular Railway, giving residents a convenient and quick way to commute into San Jose and beyond. But EV&H also accommodated the automobile by installing macadamized streets—a system that compacted stones of graduated coarseness for a smooth and mud-free driving surface. Wide concrete sidewalks lined wide parkways enhancing the parklike feel of the neighborhood. Over 300 Mexican fan palms were installed at 25-foot intervals along the parkways covering each block. The grand entrance boulevard, Palm Haven Avenue, greeted the visitor with Mission Revival–style pillars, or electroliers, flanking each side, with hanging lanterns and planted urns. In the middle as one entered was an island on which a Mission Revival trolley wait station was erected to shelter commuters as they waited for the next trolley. Behind the wait station and along a broad central median running down Palm Haven Avenue were Canary Island date palms, also planted at 25-foot intervals leading up to a central triangular, grassy plaza. Over an acre in

extent, the plaza was planted with a collection of trees in formal layout such that they fell into alignment when one stood in the correct locations. More Canary Island date palms sat in the plaza in addition to deodar cedars, weeping mulberries, and a rare California nutmeg. In 2004, all trees in Palm Haven's public areas originally planted in 1913 were designated "heritage trees" and protected under the city charter of San Jose. It remains the largest coordinated planting of heritage trees in the city and is a landmark that can be seen from airplanes on their landing approach to Mineta San José International Airport as well as from nearby highways and city streets.

Winding along the west side of the central plaza was the fittingly named Plaza Drive, the longest in the tract. It, like Clintonia Avenue on the adjacent block, terminated on the south side of the tract with a pair of pillars like those at the Palm Haven Avenue entrance. All of these elements of curving streets, a boulevard-style avenue, coordinated tree plantings, and architectural elements created a residential scene fresh and exciting to 1913 Palm Haven visitors. "We have created the setting. Now is the time to build" was the call to action in a newspaper advertisement, and building came with a whole set of requirements that would create a distinctive environment that fit the setting.

EV&H created a Building and Architectural Department to assist buyers with plans for constructing their new homes. Many of the first homes built in Palm Haven were designed by the prolific and popular local architect Frank D. Wolfe, who was very likely one of the architects assisting the department. His design of a Mission Revival house at 747 Coe Avenue bears such a striking resemblance to the nearby entrance pillar that the late architectural historian and Wolfe author George Espinola postulated that the pillars were Wolfe's design. And with so many other homes designed by Frank D. and son Carl J. Wolfe and built by brother Ernest Linwood Wolfe, or designed by others who worked under Frank, Espinola remarked, "You might as well call it Wolfe Haven!"

But other noted architects were designing custom homes for Palm Haven as well. Property deeds came with requirements that home-construction costs meet minimums determined by the location and size of the property. Generally, the properties at the entrances and surrounding the plaza had the highest minimum costs. Many required the home to cost no less than $3,500 to construct—a premium in 1913, when both land and a fully built house could be purchased for the same price or less. The deeds also set forth property setbacks, new to residential real estate at the time, so that each property had an adequate amount of green space in front leading to the public sidewalk as well as to the sides to allow access to the rear of properties for utility easements. Power and sewer lines were located at the rear of properties so the palm-lined streets would provide unfettered views. These types of development restrictions became the foundation for today's zoning codes used in cities across the nation.

The result of these requirements produced architect-designed, custom homes of refinement set on garden lots with green space and fresh air on all sides. The allure of the residence park inspired the first wave of departures from the noisy and dirty urban centers of the nation. But while Palm Haven delivered all of the elements of the Garden City–style residence parks, it possessed one differentiating factor that would have a profound impact on who chose to move there.

EV&H secured Palm Haven's "position among the well-known residence parks of California" with St. Francis Wood and Forest Hill residence parks in San Francisco by including a very unusual future requirement of property holders. All deeds to property in Palm Haven made the holder a part owner in an incorporated entity that would own and care for all the public spaces of the development. By a tax levy, the corporation would fund grounds maintenance, street and sidewalk maintenance, police and fire protection, utility-infrastructure maintenance, service fees for public areas, and general administration. In effect, Palm Haven was to become its own "city." The date originally set for this to occur was January 1, 1915, but real estate sales across the nation came to a standstill during World War I, and many of Palm Haven's parcels had not yet been purchased, so incorporation was delayed until 1917.

The opportunity to be one of only 130 (or fewer) property holders who controlled their own destiny proved to be the most fascinating and powerful draw for buyers who craved an opportunity to chart

their own courses. They maintained access to the local urban center but remained independent of and unchained by its demands. It was, in a way, the fulfillment of Taft's declaration of the union of the right of liberty with the right of property. This small clause in the property deeds that required Palm Haven to incorporate into its own "city" drew some remarkable individuals who left an enduring mark on local, regional, and national history that can still be felt today. No other neighborhood in the San Jose area before or after Palm Haven was created with this distinguishing independence, and none could claim such a concentration of history-making residents.

In this book, photographs and other imagery will take the reader on a journey of firsts, political liaisons, artistic endeavors, and business networking that rivals all the synergistic collaboration boasted by the entrepreneurs of today's high-technology–based Santa Clara Valley (or Silicon Valley). The original Palm Haven development map is shown in the last pages of this book but includes current addresses in their approximate locations. Addresses in Palm Haven changed in past years, so only current addresses will be used in this book for clarity. Many properties were combined in early years to make much larger, contiguous parcels, but after subsequent generations took possession of those properties, many were subdivided again so that as of this publication, there are again just 130 parcels in the Palm Haven subdivision.

Palm Haven voted to allow itself to be annexed into the city of San Jose in 1922, but the annexation changed little. It still collected a tax levy and took care of its own business in spite of requests from San Jose officials to turn over its functions. It was not until the 1930s that a dispute within Palm Haven over the tax levy finally resulted in the dissolution of its incorporation and the turning over of everything to San Jose. In 1987, the city performed a historical survey of selected parts of the city and designated Palm Haven a Historic Conservation Area. The designation adds another layer of review to any proposal to change the physical exterior of its historic homes. Many of Palm Haven's homes today are well maintained in their original conditions. Others have received additions reflecting the growing needs of the generations that succeeded the initial families who made the area their home in the early 1900s.

In 2002, Palm Haven residents formed the Palm Haven Restoration Committee to restore and improve the area's historic streetscape. This included a complete restoration of the seven historic pillars, or electroliers, with functioning lanterns. Custom molds were fabricated to replicate the original urns depicted in early photographs. In addition to the pillars, the committee raised funds to pay for rehabilitation of the four vintage streetlamps, originally installed in 1923, and replaced all street signs with "heritage" poles to match the vintage streetlamps. All the work culminated in the 2008 installation of a plaque commemorating these efforts and outlining Palm Haven's history. The plaque was mounted on a pedestal at the tip of the central plaza, which contains a time capsule from November of that year.

Palm Haven's prominence in the San Jose area was frequently covered in local newspapers. San Jose's primary newspaper was originally two papers published by separate companies. Later, the two papers were published by the same company, with morning and evening editions. Eventually, the evening edition was dropped. The names of these many newspapers are similar but different. For simplicity, references to "the newspaper" in this book refer to any one of these permutations unless specifically noted. Walking-tour maps preceding each major section and the address map on the last page are included for reference and as an interesting way to tour the neighborhood. There are many more photographs, newspaper articles, and pieces of information about additional Palm Haven residents that could not be included in this book, but these are being added to www.palmhaven.info all the time. A special index of houses featured in the book as well as names and designers has been created on www.palmhaven.info and should serve to augment the reader's experience and provide visitors with a guide to the sites and remarkable history of Palm Haven, California.

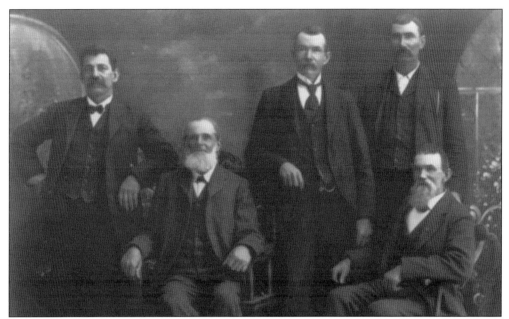

HERSCHBACH BROTHERS, C. 1900. Pictured here are, from left to right, brothers Robert Joseph, William, Henry, August F., and Charles. The Herschbach family remained in Illinois and states east, but Robert Joseph was on the move and had been west to Oregon before he moved to San Jose with sons Thomas, Robert C., and Harrison. Thomas became a highly successful real estate developer, and Robert C., a builder. (Courtesy of Arthur Herschbach.)

POSTCARD, JULY 5, 1922, POSTMARK. This postcard was sent just one month before Palm Haven agreed to be annexed into the city of San Jose. It is addressed to Mrs. L.D. Bohnett in "Palm Haven, Cal."—the destination address claimed by Palm Haven's independent status. The US Post Office Department introduced a two-digit postal zone for larger cities in 1943 and the zip code system in the 1963. (Courtesy of John Hops.)

One

CREATING A HAVEN
A 19TH-CENTURY LEGACY TAKES FORM

I am the master of my fate: I am the captain of my soul.

— from "Invictus," by William Ernest Henley,
late-19th-century English poet

In 1883, San Jose pioneer Amasa Eaton and his 10-year-old son Alfred planted two palm trees in the front yard of their home on North First Street. Amasa was the president of the San Jose Light & Power Company and a big force in efforts to electrify the city in the late 1800s. He went on to be director at the Bank of San Jose for many years while leasing and maintaining large land holdings in and outside the bay area. Alfred later built up a respectable printing business (the Eaton Printing Company) and eventually took over the family's real estate and mining interests. Three years after Amasa's death, Alfred honored his father's fondness of palms with the creation of a haven for their favorite tree.

Ashley Vestal and Thomas Herschbach joined Eaton to create Palm Haven late in 1912. Ashley's father, Dewitt Clinton Vestal, was also a California pioneer and prominent San Jose leader, active on the city council for 12 years. Like the Eatons, he had been involved in mining interests in the past but was also a great outdoorsman and played a key role in reserving the land for San Jose's Alum Rock Park for future generations. Herschbach and brothers Robert C. and Harrison were eager to develop Palm Haven lots with the latest and most contemporary homes.

When Palm Haven opened on March 15, 1913, San Jose was so thrilled with it that hundreds of people would visit the tract on weekends just to look, but with no purchase intentions. EV&H encouraged it: "No one will be importuned to buy!"

The Waiting Station at Palm Haven, at the Junction of Palmhaven, Bird and Coe Avenues.

To

interest

one hundred

and

thirty

people

There are only one hundred and thirty lots in the tract. This announcement and the talks to follow are designed to give full information to all, although but few can benefit.

is destined to be one of the finest residence parks in California. Just why we shall explain in later talks, or you can look over the ground, improvements and restrictions and draw your own conclusions.

With Palm Haven we make our initial appearance as a realty firm. It is our hope and belief that Palm Haven will always be a matter of pride and satisfaction to us—and to those who make their homes there.

Palm Haven will be formally opened in several weeks—but owing to the interest already manifested by the public, and that all may be on an equal basis, we will run Sunday announcements from now on.

Eaton, Vestal & Herschbach
Owners,
522 Bank of San Jose Bldg.
Phone S. J. 1929.

PALM HAVEN OPENING ADVERTISEMENT, 1913. EV&H introduced Palm Haven to the public via numerous advertisements such as this in the *San Jose Mercury and Herald* newspaper. This particular advertisement heralds the opening one month in advance and depicts the Mission Revival–style trolley wait station to be built at the main entrance to the tract. The Peninsular Railway was operating a line that ran along Palm Haven's east and south borders on its way from downtown San Jose south to the small town that would later become the city of Willow Glen. But the trolley system's days would not last much longer. By the 1930s, the motor coach (bus) had been invented, and the old urban railways were being undermined by changing attitudes and the "Great American Streetcar Scandal." Palm Haven residents fought to keep the line active to their stop in those final years but eventually relented to the transportation revolution fueled by cheap gasoline and affordable automobiles. (Courtesy of Michael Borbely.)

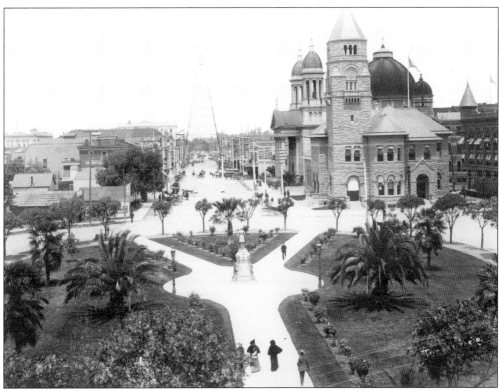

SAN JOSE CITY HALL PLAZA, C. 1900.
Established as the geographical center of San
Jose, the San Jose City Hall Plaza contained a
grassy, triangular area planted symmetrically
and punctuated by a palm tree in the
center; it bore a remarkable resemblance to
the central plaza of Palm Haven. (See the
advertisement on the opposing page.) In this
view from city hall looking down Market
Street, the main post office building stands
proud with its clock tower cupola—which
would be lost in the 1907 earthquake.
(Courtesy of the San Jose State University
Library Special Collections Department, John
C. Gordon Photographic Collection.)

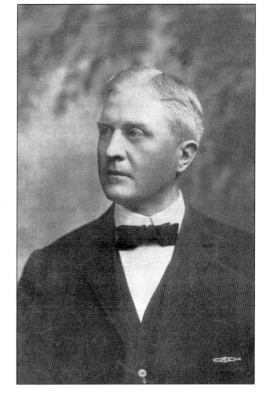

MAYOR THOMAS MONAHAN, 1912. Thomas
Monahan's two-year mayoral term began
in 1912. He and members of the San
Jose City Council, San Jose Chamber of
Commerce, and other city officials were
taken by automobile to see Palm Haven
on its opening day. "The work of the
architects is a masterpiece, and San Jose
could wish for no prettier or more exclusive
residence district," said Monahan.

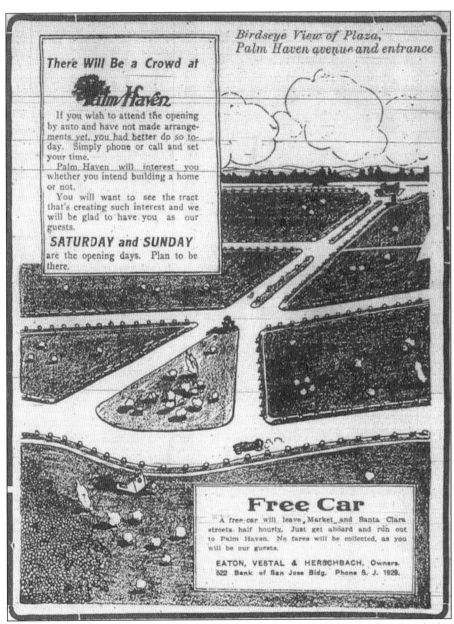

PALM HAVEN BIRD'S-EYE VIEW, 1913. This advertisement appeared just a few days before the opening of Palm Haven. The main entrance to the tract is toward the top of this illustration, where the trolley wait station can be seen on a small island. Closer examination reveals a small structure toward the bottom sitting across Plaza Drive from the central triangular plaza. This was a sales office constructed to match the Mission Revival–style trolley stop. The trees and vegetation depicted in the plaza are not accurate to the actual plantings. A carefully planned layout resulted in the planting of just over one dozen trees to create sight lines as one moved in and around the plaza. However, the perfect rhythm of the palm trees lining the streets is accurate. The beauty from this ordered design was paramount to creating an enduring streetscape. The tree placement was not to be altered, and therefore when houses were built, driveways often had to be routed around the trees. (Courtesy of Michael Borbely.)

EATON PRINTING COMPANY EXTERIOR, c. 1900. Though this photograph was taken while Alfred Eaton owned the Eaton Printing Company, by 1913 he had sold it. Because of its fine reputation for printing and binding top-quality books and other materials, the subsequent owner kept the name. It was located in the center of San Jose's downtown business district, at 175 West Santa Clara Street.

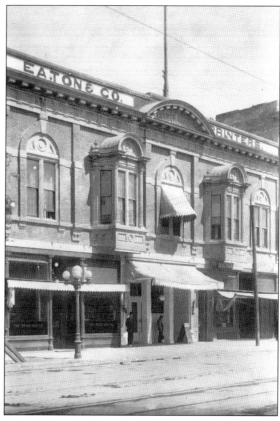

EATON PRINTING COMPANY INTERIOR, c. 1900. In 1900, Alfred Eaton would have only been 27 years of age while owning and operating his printing business. Before he became sole owner, he was in the business as partner in the Smith-Eaton Printing Company. It is pure speculation, but the tall fellow on the left bears resemblance to an old photograph of a young Amasa Eaton, Alfred's father.

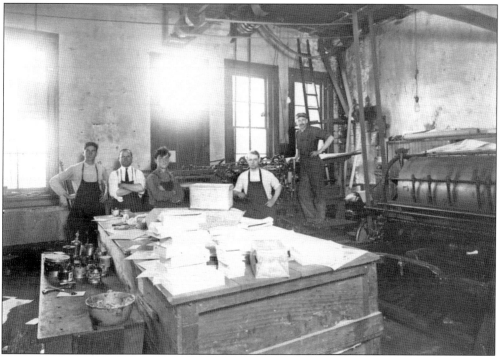

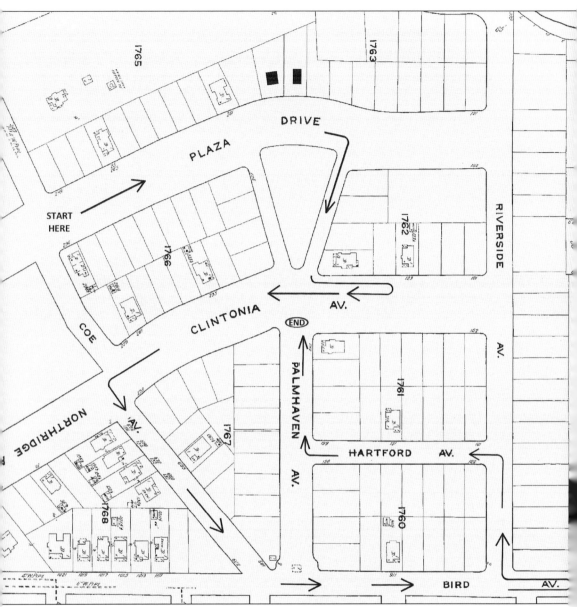

WALKING TOUR OF "THE FIRST WAVE," 1915. Sanborn fire-insurance maps were used to determine the risk to an insured structure in the event of a fire. Tract maps were drawn to show access for fire protection resources, locations where water could be drawn, and enough dimensions to clarify the distances most important to firemen. As structures were built or modified, a hand-drawn plan of the structure would be put on a piece of paper and then glued to the map. As a result, viewing a map from a particular year yields a snapshot in time of what structures were present. This 1915 map is especially relevant to the first wave of Palm Haven pioneers and entrepreneurs because, while most erected their homes immediately after the 1913 opening (two more, added in 1916, are depicted with a black box), nothing else was built until after World War I. Combined with the map of current addresses in the back of the book, this makes an excellent walking-tour focus for "The First Wave."

Two

THE FIRST WAVE
1913–1918

When we lose the right to be different, we lose the privilege to be free.

—Charles Evans Hughes
early-20th-century American statesman

The first wave of buyers of Palm Haven property were generally well financed and had either already amassed their own wealth or were well on their way to succeeding in their respective fields of endeavor. The specter of war was broiling in Europe and had cooled real estate activity nationwide. When the United States declared war on Germany, personal tax rates were increased to 77 percent to finance the war effort, and real estate transactions evaporated. Ashley Vestal's father had passed away, and though EV&H had the resources to hold the tract until the real estate market improved, the owners chose to dissolve their partnership and sell the remainder of Palm Haven to Bank of San Jose president (and longtime friend of the Eaton family) William Knox Beans.

Beans tried to jump-start activity by putting the unsold Palm Haven lots up for auction on March 9, 10, and 11, 1916. The auctioneer erected a huge heated tent in the plaza and set up an expensive lighting system that would "transform the entire tract into a blaze of light" for the evening auction sessions, which began at 7:30 p.m. "No Limit, No Reserve" read the advertisements. The sale was a huge success, and the newspaper reported that over 8,000 people attended and that, on the last day, "the bidding, which was spirited throughout the afternoon, broke into a panic near the hour of midnight." The auctioneer remarked, "It has been a rare privilege to address so intelligent and refined audiences as were gathered at Palm Haven."

But it was not until after the coincident end to World War I in November 1918, and the sudden drop in infection rates from the Spanish flu pandemic, that pent-up demand for real estate development finally returned. Nonetheless, these early years in Palm Haven were the most closely linked to EV&H's original vision, and on February 7, 1917, the Palm Haven Tract Association incorporated in the state of California.

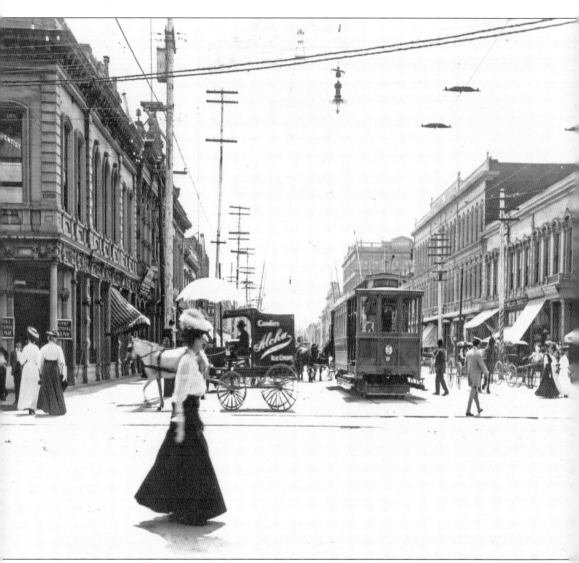

Downtown San Jose, c. 1908. On a sunny day, a trolley comes from East San Jose down Santa Clara Street, ready to cross First Street. San Jose had developed a bustling downtown core with all the city services, merchants, and public transit clustered efficiently. It was a scene well known at the time, and as San Jose was not so crowded and filthy as other, much larger cities had become, in some respects it had a good start on the ideas promoted by the City Beautiful and Garden City movements. San Jose claimed its famed fruit orchards as good a "Garden City" as anywhere, and its city hall public plaza seemed right out of the City Beautiful playbook of order, architecture, and landscaping. But the new residence park concept still resonated with families seeking a better connection to nature away from the noise and dirt of the city. The early urban trolley systems were a powerful tool to sell the utopian vision of being at home in the garden with birds, bees, and family one minute and downtown the next. It was the "life sublime."

747 COE AVENUE ADVERTISEMENT, 1913. This home was commissioned to F.D. Wolfe's architecture firm by Georgia Andrews for herself; her fiancé, William Walsh; her father, George Snowden Andrews; and a grand piano. George had been an important Wells Fargo agent from 1853 to 1875 while living in Jackson in Amador County, California. He married Jane Ranstead of Illinois, and they had children Amador (the first boy born in that county) and Georgia. Amador followed in his father's profession by also becoming a very successful Wells Fargo agent and then moving to the East Coast to run package-express companies in New York and Maryland. By the time of Amador's death in 1912, he had inherited a $300,000 estate from his uncle Lyman T. Ranstead and had amassed his own considerable wealth. He left it to family, including $15,000 for life to George and Georgia. Georgia was well known in the San Francisco Bay area for her fine piano playing and vocal oratorios and recitals. However, after her father passed away, she and William moved to Oakland in 1917 to be near William's family. (Courtesy of Michael Borbely.)

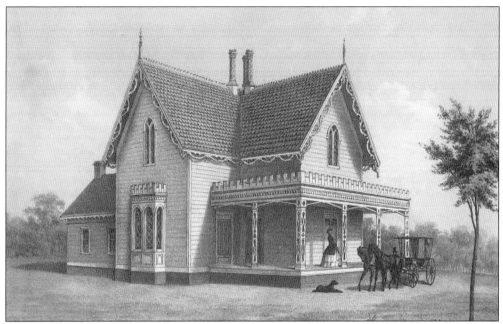

WILLIAM J. PAUGH HOUSE, 1850s. The Andrews lived in this Carpenter Gothic–style house, designed by architect Charles Parish, in Jackson, Amador County. Known as "the Heart of the Mother Lode," Amador County was created by the California State Legislature in 1854 after Jose Maria Amador's 1848 gold discovery. In 1853, George Andrews came to set up the Wells Fargo station to handle the monetary transfers. The house today is in the National Register of Historic Places. (Courtesy of Michael Borbely.)

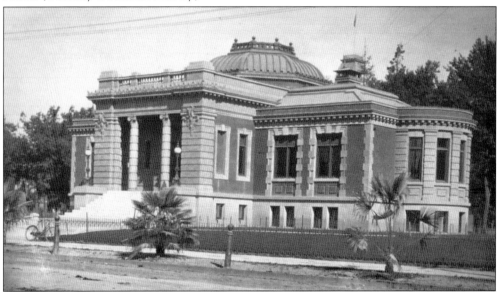

CARNEGIE LIBRARY, EAST SAN JOSE, 1920s. This photograph shows the Carnegie library at Twenty-fourth and Santa Clara Streets in what was then "East San Jose." By 1918, Charles Woods, the newly appointed head librarian for the San Jose Free Public Library system, had moved into 747 Coe Avenue with his wife, Cornelia. That same year, however, Cornelia died at home from a sudden illness. Charles left, and the next two occupants would stay only briefly.

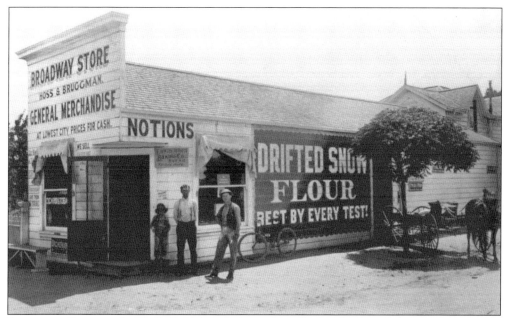

BROADWAY GENERAL STORE, 1903. This photograph predates Palm Haven, but this little corner store just across from 747 Coe Avenue remained in operation there into the 1980s. It was called Crisham's by owners Peter and Della Crisham from the 1940s to the 1970s. Coe and Delmas Avenues created the primary transit route for travelers between San Jose to the northeast and "the Willows" area to the southwest, and trolleys passed right in front of the little store.

COLLEGE OF THE PACIFIC, C. 1920. In 1914, when Charles Allen came to San Jose for the better climate, he had a considerable list of credits to his name in the practice of corporate law and in teaching international law at the University of Nebraska. He continued teaching international law at the College of the Pacific, shown here, until it moved to Stockton, California, in 1924. Allen's substantial contribution to the community continued in later years.

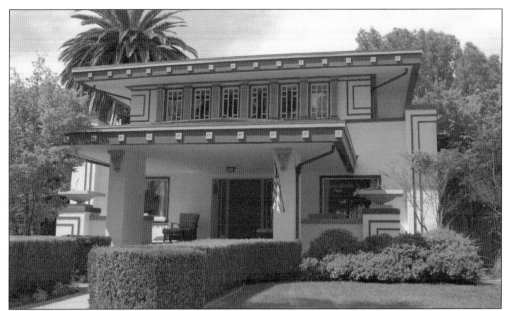

901 PLAZA DRIVE, RECENT. Designed by Frank Wolfe for Charles Allen in 1916, this Prairie School–style residence bears a resemblance to the Stockman House (pictured below). The exterior, with the exception of the square ornaments on the roof fascia, is in original condition. Robert C. Herschbach (Thomas's brother) built this home at a cost of $5,000 right after constructing 915 Plaza Drive and 925 Clintonia Avenue. (Courtesy of Michael Borbely.)

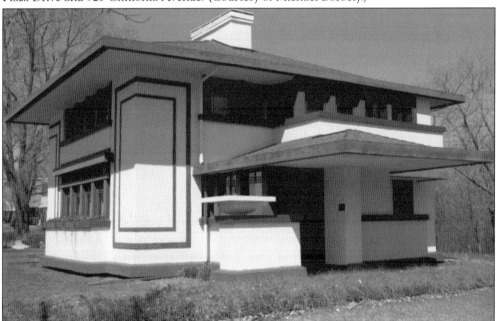

STOCKMAN HOUSE, RECENT. In 1907, the *Ladies' Home Journal* published a Frank Lloyd Wright–designed home plan of "a fireproof house for $5,000." When George Stockman requested a design for a home in Mason City, Iowa, Wright adapted his "fireproof" house and had it built in 1908. It was to have concrete walls and other novel, natural climate-control features. Frank Wolfe built his own house of concrete walls in 1920. (Courtesy of Pamela V. White.)

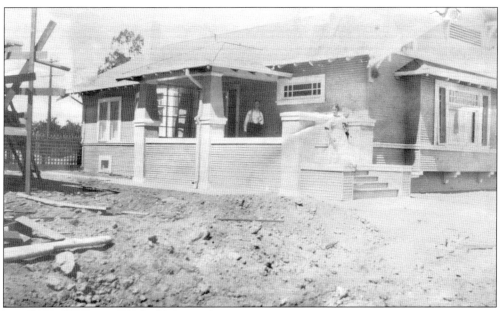

899 PLAZA DRIVE, 1916. At 29 years of age, Australian native Frederick Griffin had 899 Plaza Drive built for himself and his wife, Lydia, in 1916. In this photograph, their new home has just been completed and has yet to be landscaped. Off camera to the left, 901 Plaza Drive is under construction, with scaffolding and debris visible. (Courtesy of Nancy O'Sullivan.)

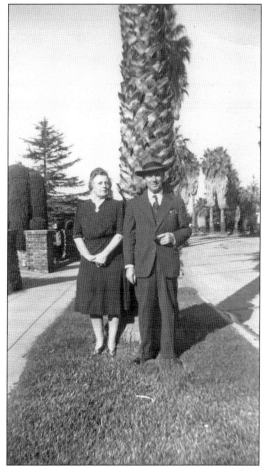

LYDIA AND FREDERICK GRIFFIN, 1930s. When Frederick's father met his untimely death while working on the railroad in Australia, Frederick's mother took the young children with her to be with family in Provo, Utah. It is believed by her descendants that she came to San Jose a few years later to earn money to return to Australia but wound up staying. This photograph was taken outside Frederick and Lydia's residence, looking north on Plaza Drive. (Courtesy of Nancy O'Sullivan.)

LOOKING NORTH FROM 899 PLAZA DRIVE, C. 1929. Frederick and Lydia had two children, John and Edward, when they moved to their new home at 899 Plaza Drive, but they lost Edward to the Spanish influenza in 1918. The next year, Donald was born, followed by Marian. Donald is pictured here to the far right with his Palm Haven pals at left. (Courtesy of Nancy O'Sullivan.)

DONALD GRIFFIN IN THE PLAZA, C. 1934. Donald Griffin poses with 725 Palm Haven Avenue in the background; he would be photographed here again years later (see page 120). His father, Frederick, was the superintendent for the Peninsular Railway—the trolley system that ran cars to the Palm Haven stop and to many locales, including San Jose, Los Gatos, Congress Springs, and Palo Alto. When the operation was purchased by Pacific City Lines, Frederick was made secretary-treasurer. (Courtesy of Nancy O'Sullivan.)

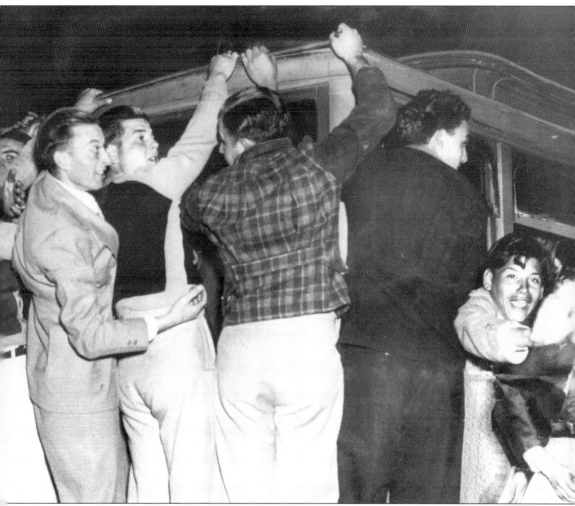

THE LAST TROLLEY RIDE, APRIL 10, 1938. During the San Jose trolleys' final hours, from 7:00 p.m. to midnight, anyone was allowed to ride for free. Kids enjoyed the nighttime fun by packing cars and riding around town. Frederick Griffin loved the trolley system, but according to new owners Pacific City Lines, it was losing money. In 1936, the company began purchasing and dismantling trolley systems up and down the coast while adding bus service. The Public Utility Holding Company Act of 1935 made it illegal for transportation utilities to sell electricity—crippling urban rail operators nationwide. Who was behind this act was questioned later in the trials of what became known as the "Great American Streetcar Scandal." In 1946, a whistle-blower said Pacific City Lines and other front companies funded by automobile, tire, and oil companies intended to monopolize transportation by destroying urban rail. In 1947, nine companies and seven individuals were indicted on counts of conspiracy to create a monopoly. After appeals that reached the US Supreme Court, General Motors was fined $5,000, and its treasurer, at the center of the conspiracy, was fined $1.

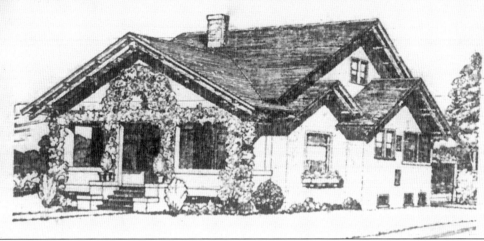

> ## Sketch of H. Thompson's Eight-Room Home to Be Erected Immediately at Palm Haven at a Cost of $5000. Warren Skillings, Architect.

701 PALM HAVEN AVENUE, 1913. The newspaper announced the erection of this home for Hiram Thompson, owner of the highly popular downtown San Jose eatery the Royal Cafeteria. Thompson, who also owned numerous commercial properties in the area, never moved into the home but instead leased it to Charles Allen until 1916, when he traded it for a downtown San Jose property where he built an apartment building. (Courtesy of Michael Borbely.)

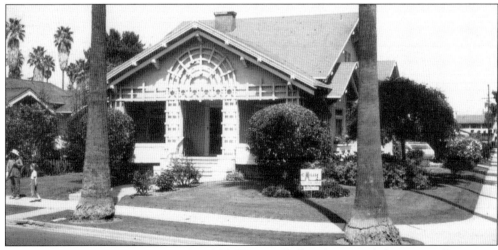

701 PALM HAVEN AVENUE, 1965. In 1965, Warren Skillings's original design is still intact at this residence. By 1900, Skillings had established himself as a leading Seattle architect doing commercial and institutional work but moved to San Jose in 1910 and became an architect of choice for the residences of affluent San Jose citizens. The adjacent parcel to the rear, 857 Clintonia Avenue (built in 1927), bears a remarkable resemblance to other Skillings designs. (Courtesy of Curt and Grace Willson.)

GARDEN CITY BANK BUILDING, c. 1910. Located at First and San Fernando Streets in San Jose, the Garden City Bank Building was a favorite of dentists and physicians for its modern features in the early 1900s. Dr. Arthur Agern kept his dental practice here and leased the residence at 685 Palm Haven Avenue from James Shonts for a season before he purchased 847 Clintonia Avenue in 1918 from the original owner and San Jose engraver Edward Wilson.

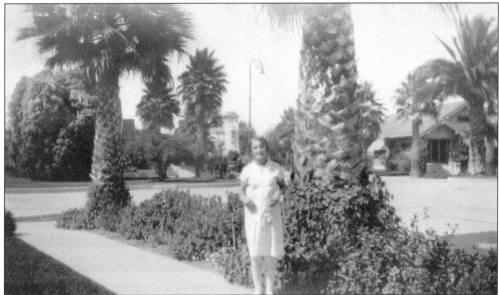

CLAIRE WOLFE, 1920s. In this northward view of Palm Haven Avenue, Palm Haven's central plaza is at left, and 685 Palm Haven Avenue, built by 1915 for Minnesotan James Shonts as a summer home, can be seen to the right. Shonts's successful land-speculating and money-changing activity in late-1800s Fergus Falls, Minnesota, had made him a prominent community member serving as a local judge and owning local businesses. He purchased the adjacent lot, where son Sydney built 868 Clintonia Avenue in 1936. (Courtesy of the Wolfe family.)

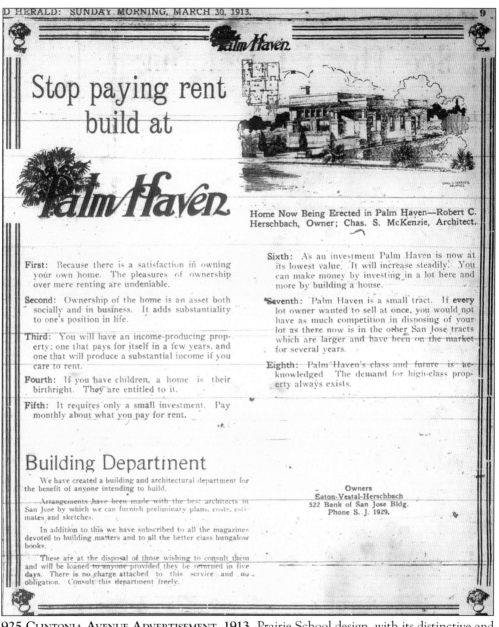

925 Clintonia Avenue Advertisement, 1913. Prairie School design, with its distinctive and forward-looking appearance, was perfect for Palm Haven buyers. It was not a style for buyers with a predilection toward conservative and common designs. Just being associated with the maverick Frank Lloyd Wright was a discomfiting prospect for some, in spite of his talents. Architect Charles McKenzie, a former Frank Wolfe partner, designed this example possibly as a speculative venture with builder Robert C. Herschbach. His designs favored the side entrance in contrast to Wolfe's tendency toward a street-facing front door. However, this has since been modified along with other parts of the exterior of this house, with the elimination of original porches and other natural spaces meant to invite outdoor living and views. The seventh point in the advertisement takes a jab at San Jose's Naglee Park and Hanchett Residence Park—Palm Haven's only similar local real estate competition in terms of land costs. (Courtesy of Michael Borbely.)

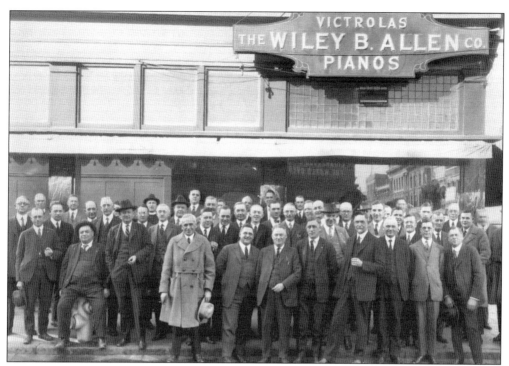

WILEY B. ALLEN COMPANY, C. 1920. William Austin, manager of the Wiley B. Allen Company, purchased 925 Clintonia Avenue in 1916. Originally a piano and musical-instrument store, it added Victrolas and other music-making inventions over time. Frank King managed the business in 1905 and 1906. Radio pioneer Charles Herrold set up his transmitter to broadcast music played from Wiley B. Allen's Victrolas in 1912—one of the first music broadcasts.

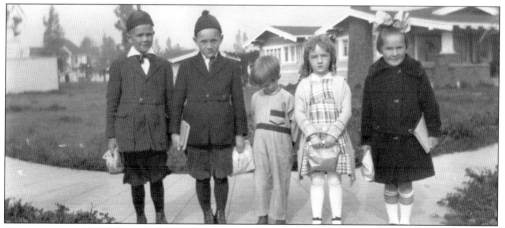

CHILDREN, C. 1920. Pictured here are, from left to right, John Bohnett, Lynn Wolfe, Lewis Bohnett Jr., June Bevens, and Claire Wolfe. Designer-builder Addison Whiteside and his brother Charles had established a successful speculative home-building business by 1913 and made 995 Clintonia Avenue (seen in the background) their next project. Their architectural legacy in San Jose today includes structures locally designated as landmarks as well as those listed in the National Register of Historic Places. Standard Oil man Frank Chapman purchased this home in 1914, and it remained in its original form until 1995, when a second story was added. (Courtesy of the Bancroft Library, University of California, Berkeley.)

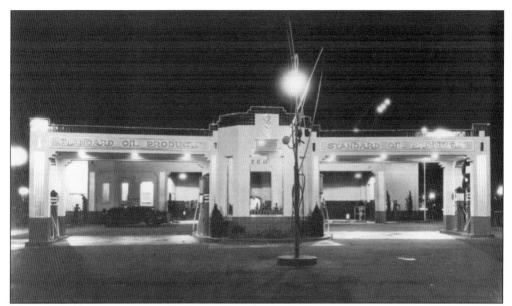

STANDARD OIL STATION, 1930S. Frank Chapman left his Warren Skillings–designed home in the Hanchett Residence Park at Busch and Tillman Avenues (1294 Hanchett Avenue today) and purchased 995 Clintonia Avenue from the Whitesides in 1914. Chapman was in regional sales management for Standard Oil by 1918 when he was promoted and transferred to Oregon. Standard Oil's flagship station on San Jose's South First Street, shown here, was along San Jose's original "auto-row."

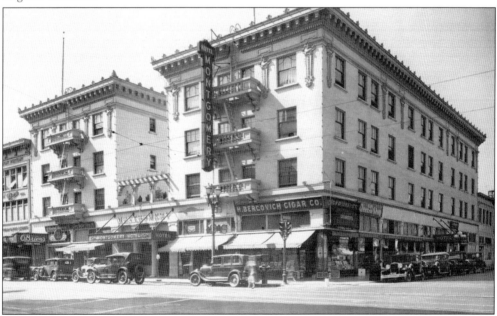

HOTEL MONTGOMERY, 1920S. T.S. Montgomery was one of San Jose's early "empire builders," and this 1911 hotel was one of his projects. His namesake realty firm was in the center of real estate activity for years. In 1924, Palm Haven residents purchased it and renamed it Biebrach, Bruch, & Moore. Hotel manager Francis McHenry purchased 995 Clintonia Avenue in 1918, but like Frank Chapman, he would remain only a short while.

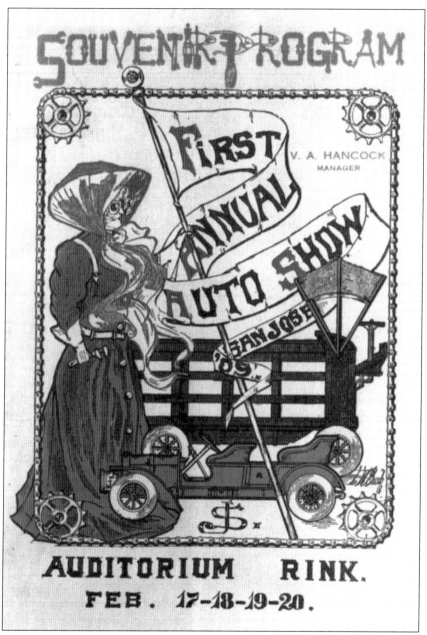

Auto Show Souvenir Program, 1909. Lysle Bush was the illustrator of this cover. Lee Wallace of the Wallace Brothers automobile repair business was an engineer-minded fellow who was drawn to building construction. By 1918, the two entrepreneurs formed the business Wallace & Bush and immediately began constructing homes for the Palm Haven Investment Company. Lysle had been watching Palm Haven from across the street when he lived at 680 Coe Avenue. He had already designed 660 Coe Avenue for Edgar Bevens; 672 Coe Avenue for his father, Frank; and 680 Coe Avenue for his family. But the allure of Palm Haven was too great for his enterprising spirit, and he made plans to build his own home in Palm Haven in 1919. While Lysle engaged in a lively real estate–development career, his artistic talent, seen in this illustration and many architectural designs, left a notable legacy.

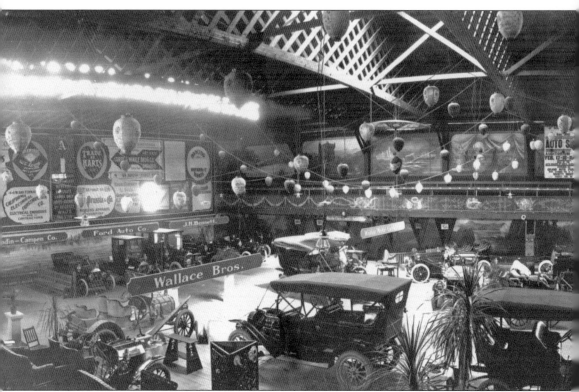

FIRST ANNUAL AUTO SHOW, 1909. Lysle Bush, mentioned on the previous page, and his father, Frank, were both irrepressible entrepreneurs. In 1907, Frank, an automobile aficionado, partnered with repairers Wallace Brothers to build what the *San Jose Mercury Herald* reported as "the largest automobile garage on the west coast." It consumed a whole city block in downtown San Jose. Lysle designed the garage in Mission Revival style and supervised its construction. The facility

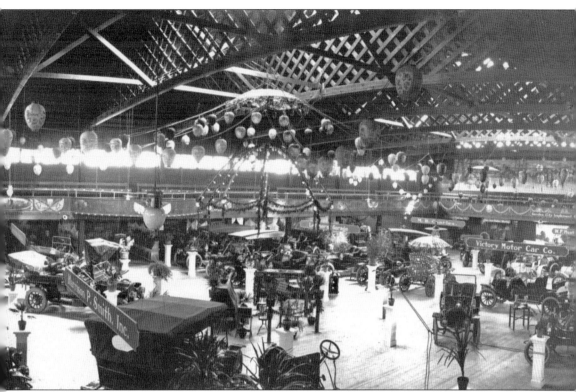

had a 150-vehicle capacity and sections provided for sales and repair. It even included sleeping rooms for customers since they planned round-the-clock operations for travelers. Furthering their promotion of the exciting technology of independent transportation, they organized the first annual automobile show in San Jose, seen here in 1909. The Wallace Brothers' sign over their display area can be seen at left. Frank retired after selling his interest in the garage a few years later.

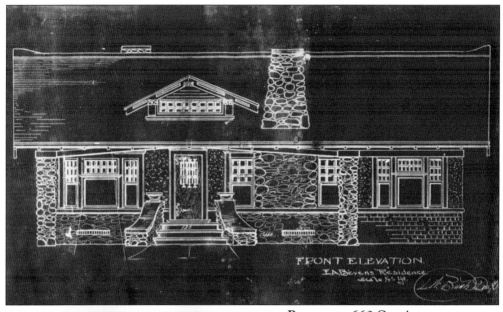

BLUEPRINT, 660 COE AVENUE, 1912. In this original elevation of 660 Coe Avenue, Lysle Bush signed the lower right corner, "L.W. Bush, Draftsman." Bush's affinity for natural materials is repeated at 680 Coe Avenue, 671 Coe Avenue, and others. Edgar Bevens, a carpenter and home builder by trade, used these plans to construct this residence for his family. The century-old home still retains its original facade. (Courtesy of Michael Sneary and Leslee Parr.)

LEWIS DAN BOHNETT AND SON JOHN, 1914. Bohnett was the son-in-law of Edgar Bevens, and this view facing east on Coe Avenue was photographed in Bevens's front yard. Young palm trees can be seen along the Palm Haven tract in the background, as can the two pillars marking the entrance to Palm Haven Avenue. The only homes visible are located on Bird Avenue across from Palm Haven. (Courtesy of Barbara L. Bohnett.)

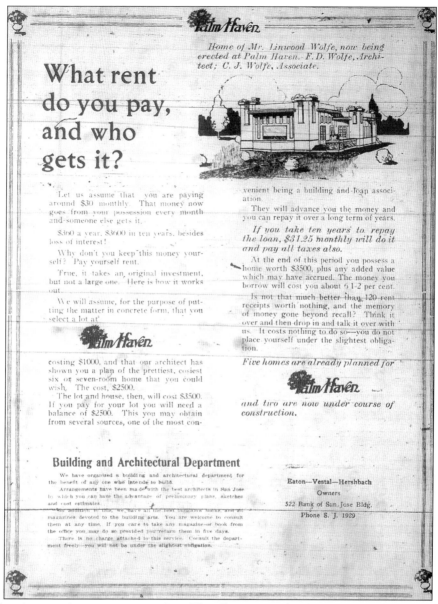

665 Coe Avenue Advertisement, 1913. This illustration of 665 Coe Avenue depicts a Prairie School–inspired design and a true Wolfe family collaboration. Ernest Linwood Wolfe, a contractor, routinely built new homes for his family, designed by his brother Frank or his nephew Carl. Ernest would live here six years before building his next Palm Haven home at 911 Clintonia Avenue. Frank D. Wolfe developed his own approach to the Prairie School style, which he was able to repeat for many residences in the San Jose area. He had just completed his own Prairie-style house near Palm Haven at 595 Brooks Avenue when he went on to design this one and 901 Plaza Drive. In this illustration, strong corner massing anchors the structure much like in prior Wolfe designs, but here the corners protrude above the roofline with large, flaring caps. This feature can be seen in photographs on the following page but is missing today. The illustration also shows an open porch, but early photographs show a roof over the porch—a feature possibly added by Ernest as a family preference. (Courtesy of Michael Borbely.)

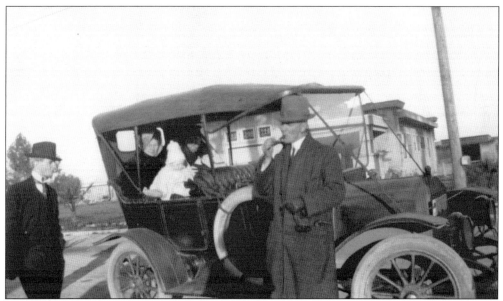

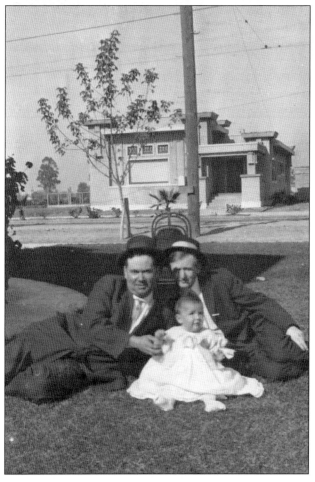

THE BEVENSES, 1910s. Seen in the background, 665 Coe Avenue sat across from the Bevenses' 660 Coe Avenue home. Edgar Bevens, lighting his cigar, later built 655 Palm Haven Avenue for his family as well as several speculative Palm Haven residences for his son-in-law Lewis Bohnett. Here, his son Willard prepares to board the automobile while his wife, Ellen, props up their grandson John Bohnett in her lap. (Courtesy of the Bancroft Library, University of California, Berkeley.)

GEORGE RANE, JOHN BOHNETT, WILLARD BEVENS, 1910s. Taken from the front yard of 660 Coe Avenue, this photograph gives a clearer view of 665 Coe Avenue's Prairie–style facade. With nothing around it for years, it became a Palm Haven symbol for the bold freethinkers looking for something that reflected their own distinctiveness. John Bohnett's great-uncle George Rane (left) and uncle Willard Bevens entertain young John Bohnett in the yard. (Courtesy of Barbara L. Bohnett.)

HUBBARD & CARMICHAEL LUMBER COMPANY, 1900s. In this image, Albert Hubbard is bent over the counter while his brother John stands behind, looking over orders. William Beal was superintendent for Hubbard & Carmichael around the time of this photograph, but in 1918 he moved to 853 Bird Avenue and took on a partner to open the realty firm Beal & Mason.

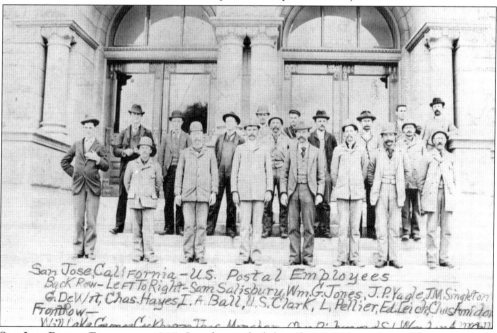

SAN JOSE POSTAL EMPLOYEES, 1905. Standing at far left in the second row, Samuel Salisbury was a local postal carrier for many years. Samuel's father, Henry, a Civil War veteran of the 15th Kansas Cavalry, began contracting in San Jose in 1888. In 1914, four years before he retired, he is believed to have built 779 Bird Avenue—a marvelous example of Arts and Crafts style, inside and out—for his family. Future San Jose mayor Thomas Monahan is in the first row, third from left.

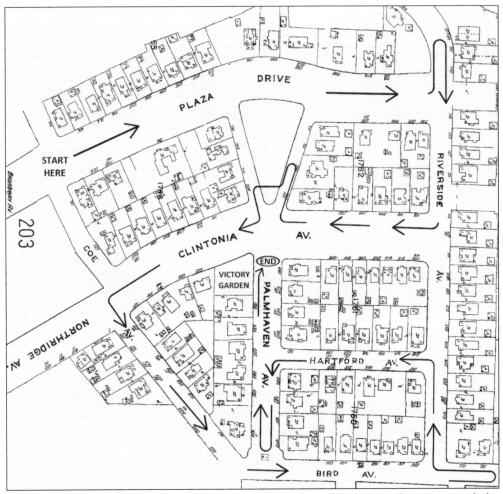

WALKING TOUR OF BUSINESS AND PROFESSIONAL LEADERS. This 1950 Sanborn map includes arrows to help guide readers through the first part of chapter three, about Palm Haven's business and professional leaders. The large gaps along Riverside Avenue suggest Sanborn anticipated the opening of a connector street between Fuller and Riverside Avenues. In 1926, residents in the Gregory neighborhood wanted a connection to Palm Haven but did not want to pay for it or for Palm Haven's services. They claimed it would make it safer for children to navigate the "blind curve" on Fuller Avenue and would encourage development in their neighborhood. Palm Haven objected based on the fact that its citizens' deeds guaranteed an exclusivity that required them to pay for upkeep based on a previously set standard. When the San Jose City Council announced it would finally make a decision on the matter, 200 residents showed up, and a kerfuffle ensued. In the end, the city sided with Palm Haven. Chapter three is ordered to follow the walking-tour arrows here. The "Victory Garden" label covers a pair of lots undeveloped by 1950. During World War II, Palm Haven residents planted a victory garden in this spot.

Three

THE SECOND WAVE
1919–1939

*Perfect freedom is reserved for the man who lives by his own
work and in that work does what he wants to do.*

– Robin George Collingwood
early-20th-century English philosopher and historian

By the time New Year's Eve arrived in 1918, an appetent America was ready to put the war and influenza behind and begin building a new era for the future. In 1919, not only did real estate activity return, it exploded. A transcontinental railroad system was in place, the automobile industry was making convenient local transportation affordable and fun, and technologies were transforming the American way of life via telephones, radios, and motion pictures. In Palm Haven, there were over 100 properties waiting to be developed for folks seeking to be a part of the independent little "city" south of San Jose.

When William Knox Beans sold the remaining parcels in 1916, he did not update the deeds' requirements for the minimum costs of new home construction, and there was no building department left to guide purchasers on what they built. Consequently, wartime inflation made those old minimums now more affordable, and the lack of oversight created the opportunity for investors to rapidly build small, inexpensive homes and still cash in on the benefits of Palm Haven. However, these investors were not outsiders. They generally built their own more pretentious homes in Palm Haven as well. The Palm Haven allure of independence and exclusivity was alive and well.

In this "Second Wave," the synergistic amalgam of freethinking spirits—all living within a few blocks of each other in an independent little city—thrust Palm Haven to a position of leadership in the San Jose region and beyond.

HAROLD HOMER KNOWLES, C. 1902. Harold was one-third owner in the Knowles, Taylor & Knowles China Company of East Liverpool, Ohio. His father, Homer, a close personal friend of US president William McKinley, was also part owner. The pottery strove to produce an American product that surpassed that of its European counterparts, and by most accounts succeeded with its specialty line of Lotus Ware—which today is scarce and highly collectible. Homer met an untimely death at age 41, when Harold was just eight years old, and McKinley was a pallbearer at the funeral. Harold maintained his family's relationships with important leaders in Ohio and along the East Coast, enjoying friendships with both McKinley and Pres. Warren Harding. Knowing Californians purchased $2,000,000 annually from eastern potteries, Harold saw an opportunity. He decided to expand by opening a factory north of Santa Clara, California, in 1922, and capitalized it with $750,000 (the equivalent of over $10,000,000 today). At the same time, he purchased 747 Coe Avenue. But his California pottery had run into a cash-flow problem about the time his friend Warren Harding died while in San Francisco. (Courtesy of the Huntington Library, San Marino, California.)

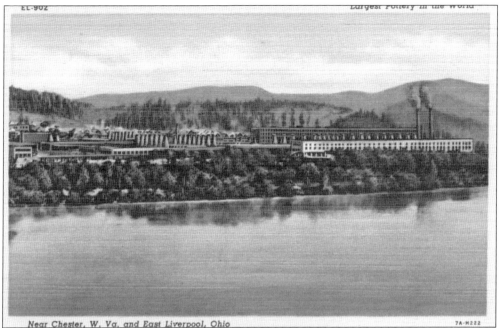

Near Chester, W. Va. and East Liverpool, Ohio 7A-H222

KNOWLES, TAYLOR & KNOWLES POTTERY FACTORY, C. 1900. A few minority creditors sought to take the Homer Knowles Pottery of Santa Clara with its substantial assets on a material lien. Harold bid to repurchase the company in court, but at the last minute, the court awarded it to a low bidder that raised its offer. Knowles, the dauntless entrepreneur, regrouped in Los Angeles to start another pottery with his previous investors. With his business plan sound, both potteries thrived. (Courtesy of Brian Hoffman.)

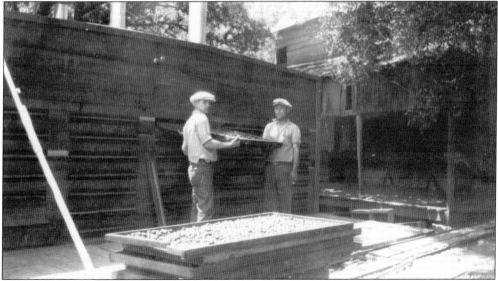

OLIVER COMPANY DRYER TRAY TRANSFER, 1920s. In 1924, William B. Oliver moved his family to 747 Coe Avenue from St. Louis, Missouri, where he had developed a successful fruit-drying factory. Seeing Santa Clara Valley becoming the world's largest fruit-canning and -drying center, he built a factory next to the railroad line on Lincoln Avenue, not far from Palm Haven. The men in this photograph are transferring trays of fruits to and from the dryer.

41

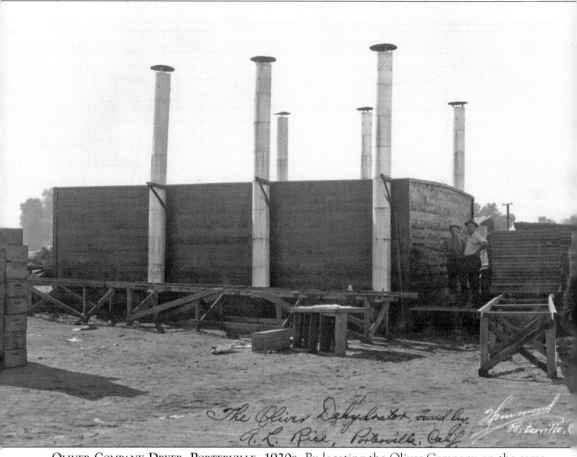

The Oliver Dehydrator, owned by Hammond
A. L. Rice, Porterville, Calf. Porterville, C

OLIVER COMPANY DRYER, PORTERVILLE, 1920s. By locating the Oliver Company on the same railroad line that served the canneries, William could ship his advanced dehydrators to the many farming centers of the state while serving the booming San Jose–area production. Oliver's oil-burning dehydrators improved on older coal- and wood-fired systems. In this photograph, a dehydrator is shown in operation in Porterville, California.

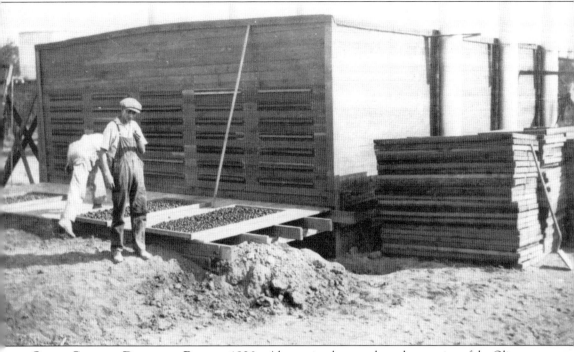

OLIVER COMPANY DRYER AND PRUNES, 1920s. Almost simultaneously to the opening of the Oliver Company, Edwin Hamlin built the Hamlin Packing Company (see page 75) adjacent to Oliver's operation. Hamlin jumped into the highly lucrative prune business and started drying the fruit with Oliver dehydrators. The two worked together to improve their respective products. In this photograph, an unidentified fellow examines the quality of a recently dried prune.

THE ESTENSEN SIBLINGS, 1930S. Norwegian immigrant Nicolai Estensen first settled in the Dell Rapids township of South Dakota and became county assessor. For his retirement, though, he sought the beneficial San Jose climate and had 985 Plaza Drive built for his family in 1938. Nicolai died in 1942, but his large family remained into the late 1940s. Pictured, from left to right, are Oscar, Ernest, Clara, Alvin, Emma, Mabel, Inga, Lowell, Mildred, Harold, and Leonard. 747 Coe Avenue can be seen in the background, across the street from the Estensen residence. (Courtesy of Kathie Curd.)

PLAZA DRIVE LOOKING SOUTH, C. 1930. Lewis Bohnett Jr.'s predilection for collecting old stuff started at an early age, as can be seen here as he tows a "project" down the road. The house rising in the background is 960 Plaza Drive. It was built in 1921 for schoolteacher Elizabeth Yocum, who also owned the lot to the south of this one, where 970 Plaza Drive would be built in 1925.

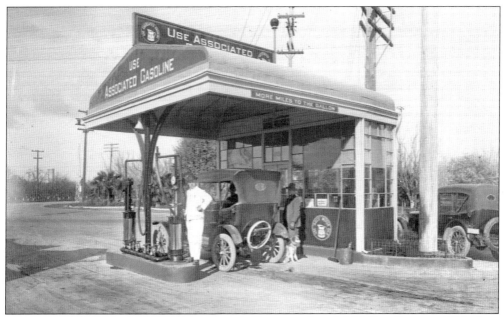

ASSOCIATED OIL STATION, 1922. John Derrol Chace purchased 960 Plaza Drive in 1925 when he became sales agent for the Associated Oil Company. His grandfather, with whom he shared the same name, was a successful gold miner and two-term mayor of Santa Cruz in the 1880s who later settled in San Jose. His father, J.R., a successful land developer, was San Jose's postmaster from 1912 to 1931.

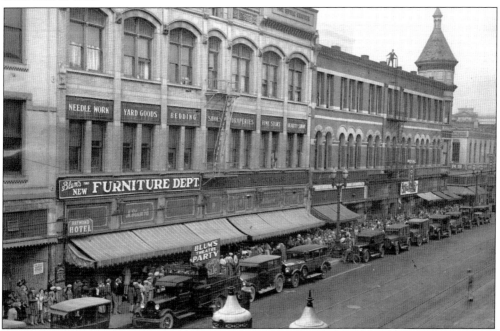

MAX BLUM & CO., C. 1925. It was a golden era for the full-service department store, and Blum's in downtown San Jose was a destination, especially during big sales like this one. Joseph Mendel was a department manager at Blum's when he purchased 945 Plaza Drive from Homer Hamlin of the Hamlin Packing Company in 1927.

CALIFORNIA PRUNE & APRICOT GROWERS ASSOCIATION, 1918. When George and Dorothy Sainsbury moved to San Jose in 1917, he helped organize the California Prune & Apricot Grower's Association and became its traveling salesman. In 1919, George had 940 Plaza Drive built at a cost of $12,000. By 1923, though, he became embroiled in a brokerage-fee dispute and quit the business. He moved to Los Gatos and worked in real estate until his untimely death in 1932.

919 PLAZA DRIVE, C. 1934. Herbert Geach had this home built for his family in 1928 by Ira Brotzman. In 1922, Geach became partner in the Garden City Manufacturing Company, a maker of children's and ladies' undergarments, and funded expansion of the operation on Willard Avenue. By 1930, he bought out his partner and took the business under his own name. It continued to prosper until World War II, when he closed the business to retire. (Courtesy of Dale and Lynn Bowers-Lingscheid.)

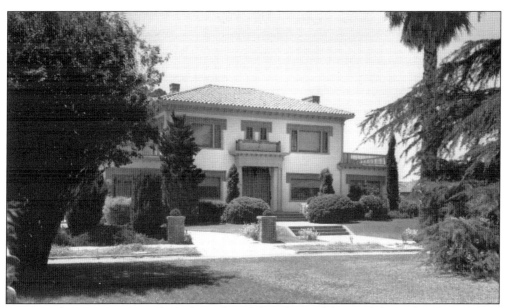

875 Plaza Drive, 1930s. Lysle Bush combined three lots and designed this Italian Renaissance Revival home for his family in 1919. It was almost finished in 1920 when he and partner Lee Wallace accepted contracts in Los Angeles to construct the Wilshire Apartment building for $825,000 and develop an 8,000-home residential tract. Bush traded his San Jose real estate and moved to the Hollywood Hills.

John Sheldon Williams, 1890s. Williams purchased 875 Plaza Drive and had it completed for his family to take up residence in 1921. He owned the famous J.S. Williams men's clothing store in downtown San Jose for decades. In addition to serving on the city council of San Jose, Williams served for 21 years on the San Jose School Board and was honored with the naming of Williams Elementary School in San Jose.

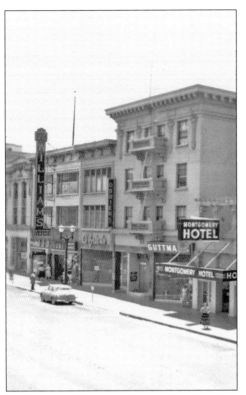

J.S. WILLIAMS ON SOUTH FIRST STREET, 1950s. Williams had moved his business to other downtown San Jose addresses before finally settling on the downtown merchant core just to the south of the Montgomery Hotel. By this time, he had expanded the business into the first chain store clothier on the West Coast, with seven stores in the San Francisco Bay Area.

ANDERSON-BARNGROVER MAIN PLANT, 1920s. Anderson-Barngrover manufactured equipment for the fruit-canning industry and, after being purchased by Bean Spray Pump in 1928, became the Food Machinery Corporation, known today as FMC. It would supply vital equipment for the military in World War II. In 1924, Rudolph Hoeller, Anderson-Barngrover's plant foreman, purchased 869 Plaza Drive with his wife, Clara, and remained there for over 40 years.

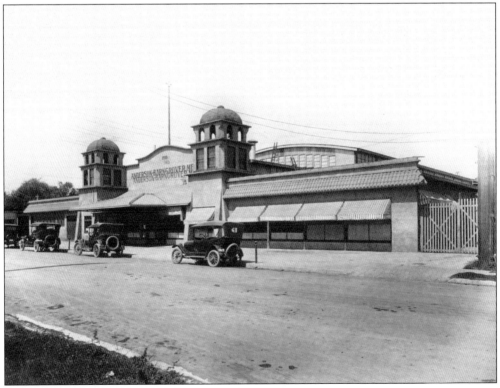

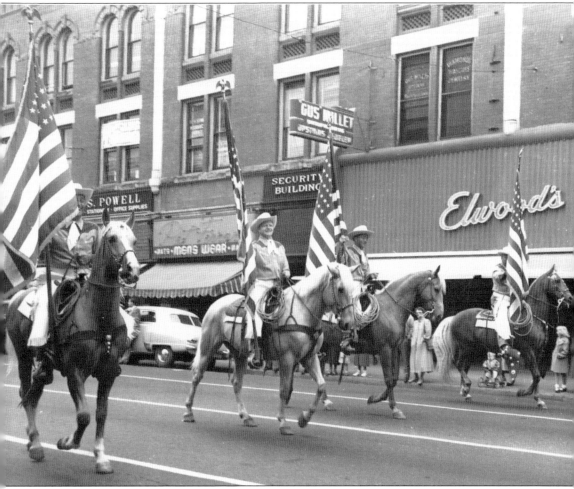

FIREMAN'S RODEO PARADE, 1940s. Raised on a farm, Rudolph Hoeller loved his horses and kept them on ranch land just outside San Jose. Hoeller was a member of the Santa Clara County Horseman's Association and can be seen riding the leftmost horse in this photograph. Also pictured are, from left to right, Floyd Oliver, Arthur "Red" Ganji, and Walter Hamburg.

O.A. Hale Department Store, 1930s. When Alan Cormack purchased 845 Plaza Drive in 1925 from Clyde Bossemeyer, he was a department manager at the O.A. Hale department store in downtown San Jose. His next-door neighbor Clara Hoeller also worked there, and both of them are likely somewhere in this staff photograph of the store's interior.

CALIFORNIA NATIONAL GUARD NONCOMMISSIONED OFFICERS, 1911. This is Company B of the 5th Infantry in the National Guard. Volney Van Dalsem, who stands in the center of the second row, would have been 18 years old at the time of this photograph. He later purchased 845 Plaza Drive in 1946, and it remained in the family until 1982. Van Dalsem built 868 Clintonia Avenue for Sydney Shonts in 1936 and 835 Clintonia Avenue for sale in 1937.

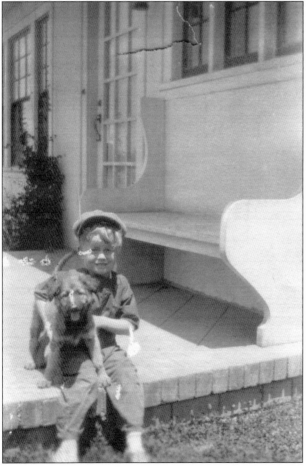

DONALD GRIFFIN AND UNIDENTIFIED NEIGHBORS, C. 1929. Donald (right) loved his dog Wolf and is all smiles when posing with him for photographers. The house directly behind Donald and his neighbors is 846 Plaza Drive. Designed in 1921 by Lysle Bush for his father-in-law, John Charles, this home is Palm Haven's most vivid original example of modernist influences in American architecture. (Courtesy of Nancy O'Sullivan.)

840 PLAZA DRIVE, 1924. Willard Follette had this home at 840 Plaza Drive built by 1922, but just after his marriage to Aileen McGeoghegan, the couple moved into the former family home of her parents in Saratoga. Clyde Bossemeyer purchased 840 Plaza Drive in 1923 and took this photograph of young Donald Griffin visiting from down the street at 899 Plaza Drive. This home was extensively remodeled in 1997. (Courtesy of Nancy O'Sullivan.)

814 Riverside Drive, 2004. Allen E. Young purchased this home from building contractor Grover Carpenter in 1932. Young demonstrated adroit business sense as a music-store merchant. In 1928, the Sherman-Clay piano distributor purchased the old Wiley B. Allen store, but it closed in 1931 under poor management. Allen reopened the store in his name and, by 1932, sold it back to Sherman-Clay. He also owned Allen's Music Emporium and others. (Courtesy of Michael Borbely.)

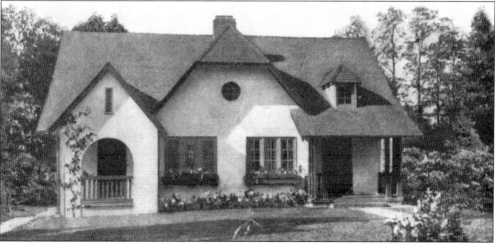

"The New Bungalow Apartment for Business Women," 1919. This headline for an article about the newly invented "double-bungalow," now commonly referred to as a duplex, appears in a *Ladies' Home Journal* in 1919 over the reversed photograph shown here. Marian Silva built one in 1927 at 755/757 Riverside Drive that was largely identical to this one, with minor differences. "It might easily be taken for a one-family home, so cleverly are the entrances handled," reads the article. (Courtesy of Michael Borbely.)

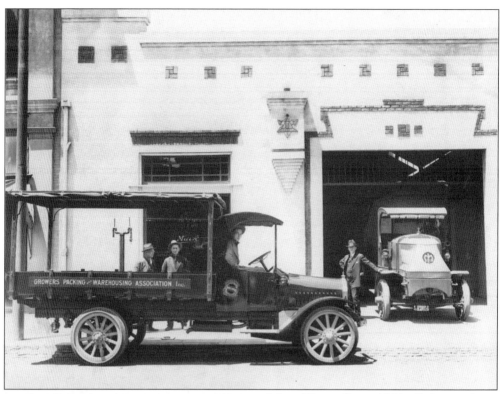

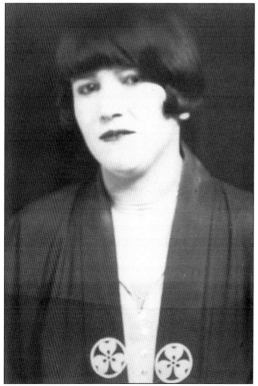

MACK TRUCK SHOP, 1920s. Robert and Frances Macke had 739 Riverside Drive built for them in 1926. At the time, Robert was the foreman at the Grower's Packing and Warehousing Association. Here, a new Mack delivery truck is being picked up for the association. The association was formed in 1917 to protect orchardists and stabilize prices. It became Sunsweet Growers, Incorporated, in 1958 and today is the world's largest handler of dried tree fruits.

ALINE RAMONA ORTEGA, 1920s. Aline is a direct descendant of the early Spanish pioneers who discovered San Francisco's Golden Gate. In 1769, her adventuresome great-great-great-grandfather Sgt. Jose Ortega was commissioned to locate the Monterey Bay, discovered 67 years earlier. Fog shrouded the bay, and the men landed northward but undaunted. Ortega pressed on and reached what is now called Sweeney Ridge. There, he saw the bay and Golden Gate spread before him. (Courtesy of Norvelle Benevento.)

ALINE ORTEGA AND FRIENDS, 1920s. Ever fashion-savvy and a consummate social organizer, Aline remained at the center of activity throughout her life. Here, she is pictured (center) in Santa Cruz with Mary Drew (left) and Loretta Kanoth. For years, Aline hosted an 11:00 a.m. Sunday brunch that became an all-day affair culminating in a formal dinner. In a 2002 interview, Aline says when she was a little girl, passing by the pillared entrance to Palm Haven, she had dreamed of owning a home there one day. (Courtesy of Norvelle Benevento.)

721 Riverside Drive, 1929. In August 1929, newly married Aline Ortega Benevento worked with builder Ira Brotzman to customize the design of her new Period Revival–style home. By building in Palm Haven, she fulfilled her childhood dream. She divorced her husband 10 years later and raised her daughter Norvelle as a single mother. But like a true Palm Haven independent, her indomitable pioneer spirit would not down. (Courtesy of Norvelle Benevento.)

NORVELLE BENEVENTO AND HER FATHER, JOHN, C. 1936. If anyone was equipped to run a household and raise a child alone at a time when women's pay was minimal, it was Aline. As the bookkeeper for various San Jose businesses, she expertly handled their finances as well as her own. Understanding a single mother's needs, she founded the San Jose Nurse's Registry and Babysitters Agency, put her daughter through college, and traveled the world like her ancestors. (Courtesy of Norvelle Benevento.)

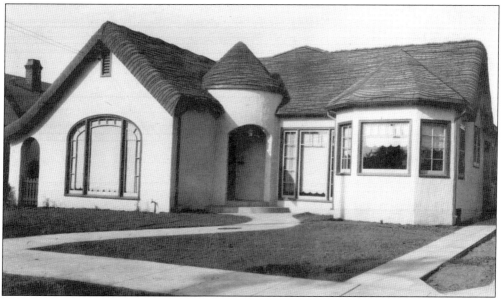

721 RIVERSIDE DRIVE COMPLETE, 1929. The newly finished Period Revival–style home draws on the French subtype form with an L-shaped plan and signature entrance tower capped by a conical roof. An octagonal breakfast nook projects at right. The wavy roof shingling mimics cottages of rural England with their natural, thatched roofs and rolled eaves. Often called Storybook style, Americans' fantasy version of the rural European cottage was all the rage—a fitting choice for Aline's dream home. (Courtesy of Norvelle Benevento.)

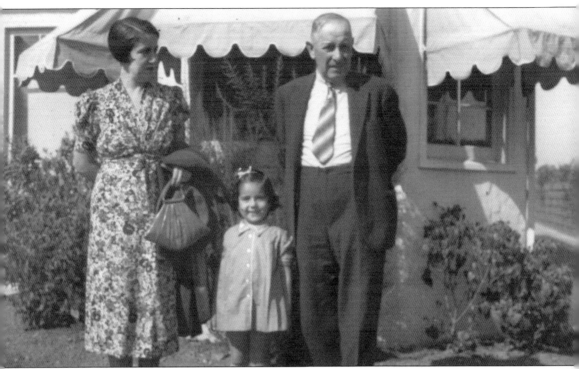

ORTEGA FAMILY, 1938. Posing in front of 721 Riverside Drive are, from left to right, Aline Ramona Ortega, Norvelle Ramona Benevento, and Jose Quintin Ortega II—three generations of the Ortega family. Aline remained in her Palm Haven home till her death in 2003. She was a charter member of the elite Los Californianos, whose members are proven direct descendants of the state's Spanish pioneers. Norvelle, born and raised in Palm Haven, remains today, and her daughter Julia is the fourth generation to reside in Aline's dream home. (Courtesy of Norvelle Benevento.)

LADY AND 715 RIVERSIDE DRIVE, 1931. Aline Ortega's wirehaired terrier Lady enjoys a birthday gift while 715 Riverside Drive in the background is under construction by George Kocher. Kocher, who had built a respectable construction business by the 1930s, oversaw construction of many local structures, including the Wolfe & Higgins–designed, Spanish Colonial Revival–style San Jose Women's Club in 1929. It was a style popular through the 1920s that he would often repeat. (Courtesy of Norvelle Benevento.)

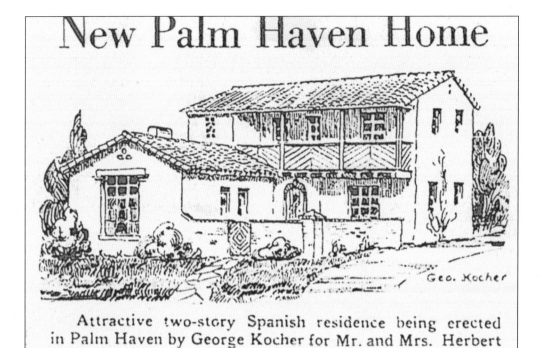

New Palm Haven Home

Attractive two-story Spanish residence being erected in Palm Haven by George Kocher for Mr. and Mrs. Herbert F. Fisher.

709 RIVERSIDE DRIVE, 1933. In this newspaper article, George Kocher's Monterey-style project is featured as the first of its type in Palm Haven. Kocher was a builder but may well have also been responsible for designing many of his projects. His brother A. Lawrence Kocher was born in San Jose and schooled at Stanford but went eastward to complete postgraduate studies and became a prominent East Coast architect, professor, and editor of the *Architectural Record*. (Courtesy of Michael Borbely.)

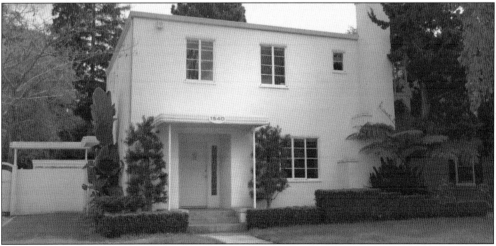

1540 CALAVERAS DRIVE, SAN JOSE, RECENT. George Kocher built this home—the first arc-welded all-steel-framed residence on the Pacific coast—in 1935. Although not a Palm Haven home, it is illustrative of Kocher's innovative work. Kocher was very interested in efficient and modern housing and would spend months at a time studying architecture and building technology in midwestern and eastern locales with his brother A. Lawrence. The work of both was improved through their collaborative studies. (Courtesy of Michael Borbely.)

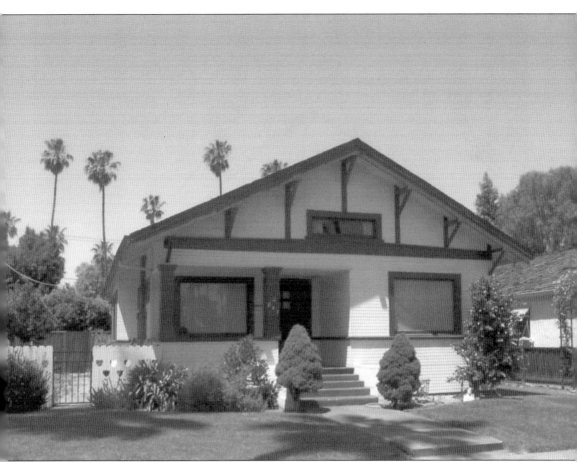

847 Clintonia Avenue, 2004. In 1921, millionaire bachelor Townsend Nichols purchased this home at age 86. In a 1914 *Los Angeles Times* interview, Nichols says he had smoked for 60 years but never in excess—one cigar after each meal and one before 10 hours of sleep. He attributes his good health to bachelorhood. "I've never been in love, never engaged, and never married, and that's why I am so well and happy," he says. "Women have put some of my best friends in the grave." The *Oakland Tribune* interviewed "California's champion bachelor" in 1920, with the article noting he was "hale and hearty and [would] go for his centennial." In his typical candor, Nichols says, "Women are fine—if you leave them alone." He was the toast of the town (in some circles). He died in his Palm Haven home six years after the *Tribune* article. Nichols's father, Samuel, served in the War of 1812 and afterward ran a general store in Ohio before going to Iowa to purchase land from the government. Later granted a land warrant for his services in the war, he accumulated thousands of acres, which Townsend inherited.

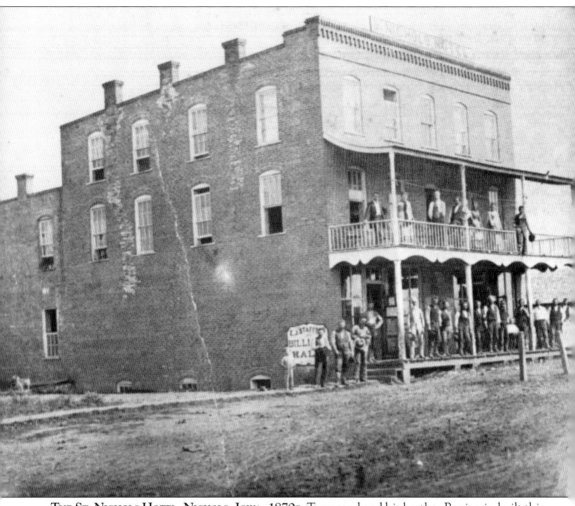

THE ST. NICHOLS HOTEL, NICHOLS, IOWA, 1870S. Townsend and his brother Benjamin built this hotel in 1870 and laid out the town of Nichols in 1871. As a boy, Townsend carved his name on trees to claim what amounted to 3,600 acres and defied anyone to take it. Vim and vigor aside, one reporter called him "a most benevolent feudal landlord." He routinely rented land worth $250 per acre for $1 per year. He left the majority of his estate to Rabbi Harvey Franklin of Palm Haven. Their parents were friends, and Townsend had taken young Harvey under his wing at age 8. But Nichols family members hired L.D. Bohnett of Palm Haven to break the will. The sensational courtroom drama played out in newspapers near and far. Ignoring the judge's warnings, Bohnett got into hot water when the court admonished him for flaying the testimony of Townsend's nurse. He accused her of adding a date to a will, to which she responded that Bohnett told her to do it. Bohnett lost the case and the appellate court dismissed it. Franklin appeased the family in a financially beneficial settlement.

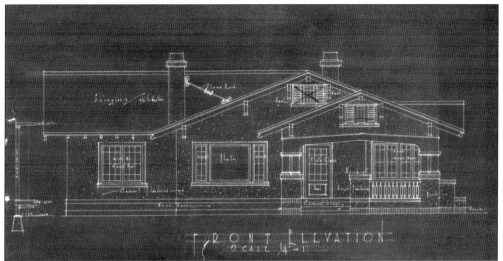

725 PALM HAVEN AVENUE BLUEPRINT, 1920. Thomas and Irene Manning had this home built in 1921. Thomas, a Union soldier in the Civil War, owned a tin shop and hardware store in Nebraska before retiring to San Jose in 1907. At the 1916 Palm Haven auction, he purchased lots from 725 all the way to the corner and two more adjacent on Plaza Drive. Thomas died in 1929, and Irene, in 1942. (Courtesy of the Alvarado family.)

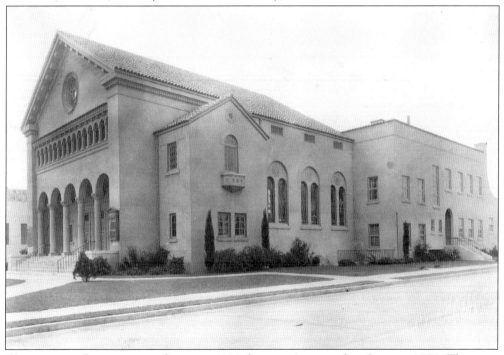

WESTMINSTER PRESBYTERIAN CHURCH, 1100 SHASTA AVENUE, SAN JOSE, C. 1929. The roots of this grand 1926 edifice can be traced back to Palm Haven. A church building committee of seven was formed that included Palm Haven residents Annie Campbell, Clarence Goodwin, Irene Manning, and Henry Bridges, the contractor who built the Manning home. The Mannings' substantial donation to the project was honored by adding "T.H. Manning" to a stained-glass window in the sanctuary—still visible today. (Courtesy of Westminster Presbyterian Church.)

704 Palm Haven Avenue, c. 1926. This home was built in 1925 by Ernest Wolfe, whose family would live here four years before selling to Lydia McKee, leader of the Home of Benevolence. Arthur W. Jenks purchased the home in 1932 after Lydia's death. Jenks, a mining engineer, often traveled the world examining deposits as a consultant. In 1907, he made Seattle news when he purchased a large property for a sum that, by today's standards, was the equivalent of nearly $10 million. (Courtesy of the Wolfe family.)

911 Clintonia Avenue, c. 1922. Ernest Wolfe built this, his second Palm Haven home, in 1920 for his family. Standing on the steps are his daughter Claire (left) and son Lynn. In 1926, he sold the home to Joseph and Edith Thompson, who remained there into the 1960s. Joseph was a manager at J.B. Inderrieden Co., one of San Jose's major fruit canneries. (Courtesy of the Wolfe family.)

LEON REA LOUPE, C. 1904. Leon's grandfather Samuel Loupe, a Bavarian Jew originally named Laupheimer, immigrated to the United States and eventually settled in Gilroy, California. Leon's father, Louis, was Gilroy's mayor from 1888 to 1892. Leon's great-uncle Thomas Rea—a California pioneer, a state assembly member in the 1870s, and a forty-niner—was also Gilroy's mayor from 1886 to 1888. The Reas owned thousands of acres of land, and Leon inherited two Rea estates that, by today's standards, were worth millions. (Courtesy of the estate of Reine Loupe Brent.)

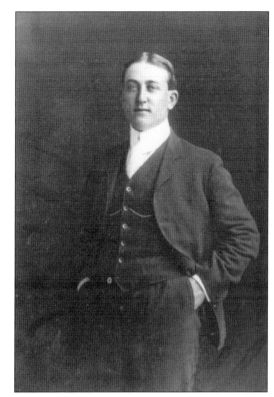

ALICE ALLEN LOUPE, C. 1904. This photograph was taken on the occasion of Leon and Alice Loupe's wedding. Alice's father, Frank Alfonso Allen, was a successful local orchardist and raised his children in the Frank Wolfe–designed, Prairie-style residence on Cypress Avenue in San Jose. Coming to Wolfe-infused Palm Haven must have been like coming home for Alice. (Courtesy of Brad Fanta.)

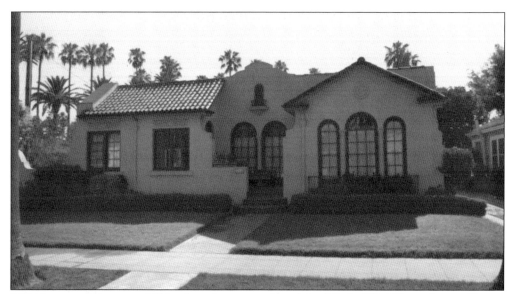

928 Clintonia Avenue, 1980s. Leon Loupe purchased this Wyckoff & White–designed home in 1924 while working at Biebrach, Bruch, & Moore. Leon later worked for clothier J.S. Williams for many years, in spite of his inherited wealth. Today, Loupe Court and Rea Street in Gilroy, California, honor the names of his pioneer ancestors. A second-story addition to this residence was completed in 1990. (Courtesy of Michael Levine and Theodora Koumoutsakis.)

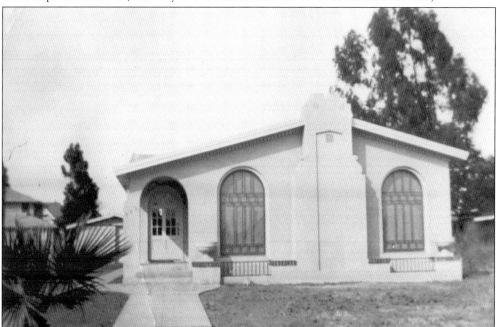

929 Clintonia Avenue, 1924. While living at 911 Clintonia, Ernest Wolfe obtained a permit in October 1923 to build this bungalow for $4,900. Its Californian and modernist tendencies suggest other design work by nephew Carl Wolfe—particularly its prominent stepped chimney and deft conservation of ornamentation. But the unusual window muntins in the two arched windows produce a strikingly fresh facade. Upon its completion, Wolfe sold the structure to telephone engineer Norman English. (Courtesy of Norman and May English family.)

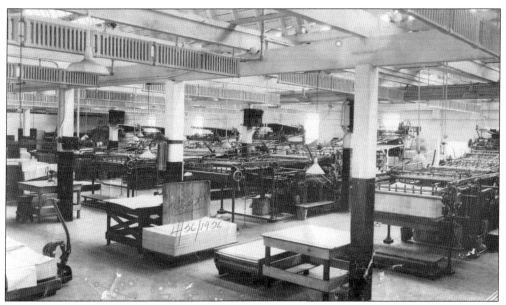

Muirson Label Printing Company, 1926. In 1924, the superintendent for the Muirson Label Printing Company, Luke Kelly, purchased 935 Clintonia Avenue from Ernest Wolfe, who had just completed building it. Wolfe had purchased the property from Brice Sainsbury, uncle of George Sainsbury, in 1923. Kelly was very active in civic affairs, including the chamber of commerce and Rotary, and was general of the local Civilian Defense League.

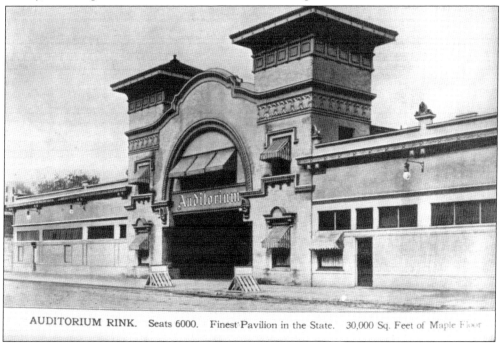

AUDITORIUM RINK. Seats 6000. Finest Pavilion in the State. 30,000 Sq. Feet of Maple Floor

The Auditorium Rink, 1900s. Opened in 1907, San Jose's Auditorium Rink sat directly across from city hall. Amos Tucker, a convivial entertainment promoter who operated a number of shooting ranges around San Jose, ran this popular skating and entertainment center in the 1919s. His daughter Ruth Tucker Saunders lived at 995 Clintonia Avenue.

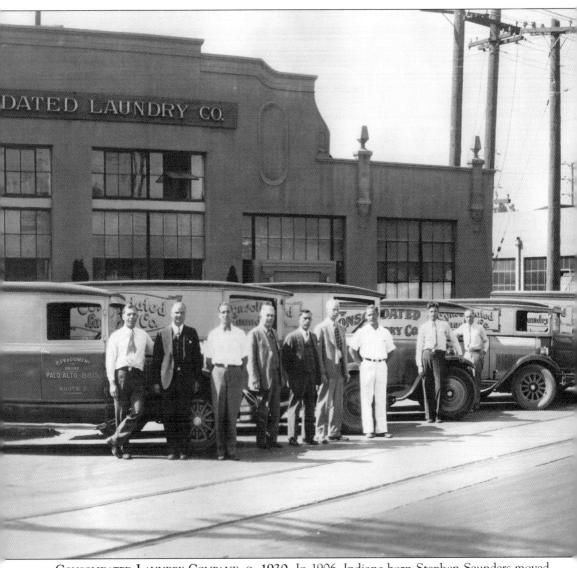

CONSOLIDATED LAUNDRY COMPANY, C. 1930. In 1906, Indiana-born Stephen Saunders moved to San Francisco, where he worked as a barber. In 1911, he moved to San Jose and started the Valley Towel Supply Company with partner W.A. Katen, the first business of its kind in the city. By 1916, they had absorbed competitors and aptly named their business the Consolidated Laundry Company. In 1917, Eli Bariteau purchased Katen's interest and remained a partner until

Saunders' death in 1946. In 1919, Saunders and his wife, Ruth Tucker, purchased 995 Clintonia Avenue, where Ruth remained into the 1970s, long after her husband's death. Stephen, standing second from left, was known for his kind treatment of employees and provided nursery care for women with children.

671 Coe Avenue, 1921. In 1916, the Palm Haven Investment Corporation (PHIC) was formed by five residents to develop Palm Haven property for profit. They hired construction developers Wallace & Bush to build homes like this one, and on October 29, 1919, Wallace & Bush announced it would be constructing 22 homes in Palm Haven for PHIC. (Courtesy of the San Jose State University Library Special Collections Department, John C. Gordon Photographic Collection.)

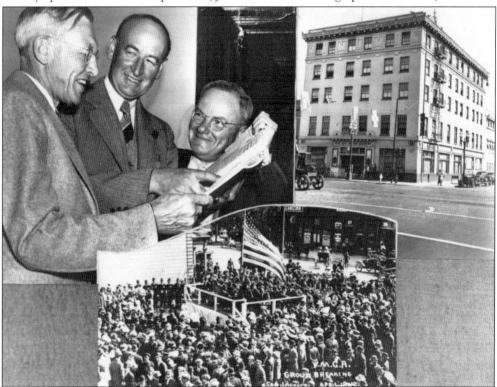

YMCA Building, 1912. George B. Campbell purchased 671 Coe Avenue when it was completed in 1921. Campbell was on the board of directors for the Security State Bank and held various positions within the bank over the years. Very active in community fundraisers for children and the needy, he worked to put together the funding necessary to construct the YMCA building in this photograph montage celebrating its ground breaking and dedication.

GEORGE B. CAMPBELL, 1928. The
Rotarian president in 1928, Campbell
came to the rescue of the YMCA's
Camp Roberts in 1936. The camp
had lost its lease, so Campbell and
Frank Lewis of 857 Clintonia Avenue
launched a fundraiser to purchase 12
acres near Boulder Creek, in the Santa
Cruz Mountains, for $6,500. When
Campbell passed away in 1944, the
YMCA renamed it Camp Campbell in
his honor—a name it holds to this day.

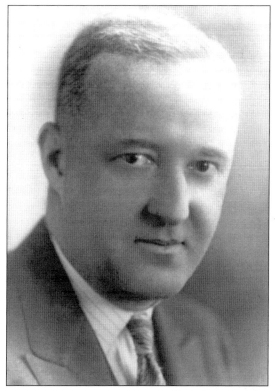

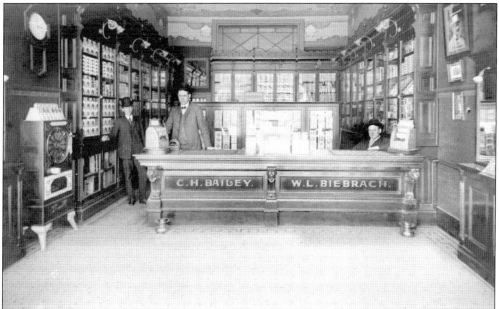

BAILEY & BIEBRACH, TOBACCONISTS, 1910s. William Biebrach (second from left) had long
established a career as a tobacconist working at various cigar shops in downtown San Jose when
he opened his own shop with partner C.H. Bailey. Biebrach purchased 665 Coe Avenue in 1924.
His cigar-shop patrons gave him the inside track on downtown San Jose politics, and soon he
had aspirations of his own.

THE GREAT MAUSOLEUM ROTUNDA, 1934. William and Maude Frost had 655 Coe Avenue built for them in 1924. Frost was the Guaranty Building & Trust Company secretary and, working there with William and Urban Sontheimer, became involved in the Oak Hill Improvement Company. The Sontheimers founded the company to take over Oak Hill Cemetery, improve it, and construct a mausoleum on-site. In 1928, the Albert Roller–designed Great Mausoleum was built.

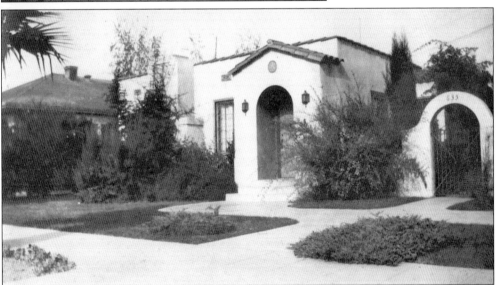

635 COE AVENUE, 1930S. This Carl Wolfe–designed home built in 1923 was purchased by dentist Lelande Jackson. A St. Claire Club member, Jackson maintained his dental practice in the Garden City Bank Building. His back-door neighbors Klein and Krause would use his yard to wheel their parade-float creations out a back door built in Klein's garage at 636 Palm Haven Avenue. (Courtesy of Mariellen Klein.)

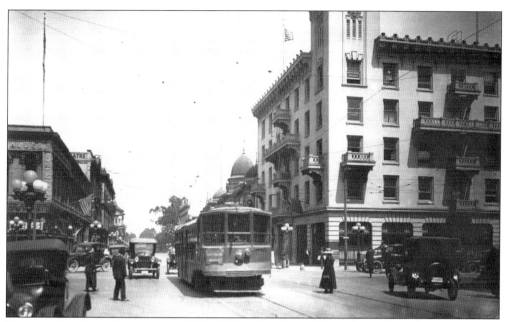

BANK OF SAN JOSE BUILDING, C. 1921. When Dr. Samuel Saso located his dentistry in this building, he hired L.C. Rossi to build 609 Palm Haven Avenue for his family in 1925. His wife, Irma, was a daughter of Benjamin Cribari, the patriarch of the San Jose vintner family. Many Italians had located along Bird Avenue in the early 1900s. Across from the Sasos on Bird Avenue were Pasquale and Jean Cribari in a large, block-spanning property.

1066 BIRD AVENUE, RECENT. Farther down Bird Avenue, Fiore and Maria Bisceglia Cribari built their Italian Renaissance Revival home about 1921. Fiore and his sister Irma Saso were Benjamin and Josephine Cribari's children. By this time, Fiore was handling the growing Cribari family enterprise with some 3,000 acres in Northern California. His wife, Maria, was from the Bisceglia family, also successful local vintners and canners. The home's design is attributed to Herman Krause. (Courtesy of Michael Borbely.)

73

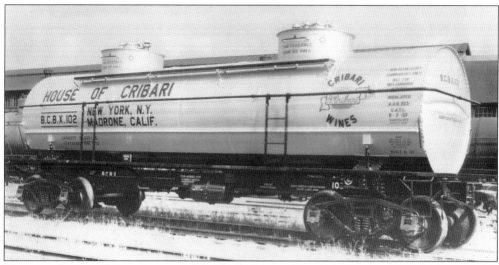

HOUSE OF CRIBARI RAILCAR, 1920s. Like the D'Arrigos (see pages 79–82), the Cribaris leveraged their families' bicoastal presence by shipping California production to East Coast markets. Upon their golden wedding anniversary in 1936, Benjamin and Josephine received a blessing from Pope Pius XI, a medal from King Victor Emmanuel III of Italy, and an iron wedding ring from Benito Mussolini. The Cribaris sold the volume business in 1944 for millions and maintained a smaller specialty wine operation.

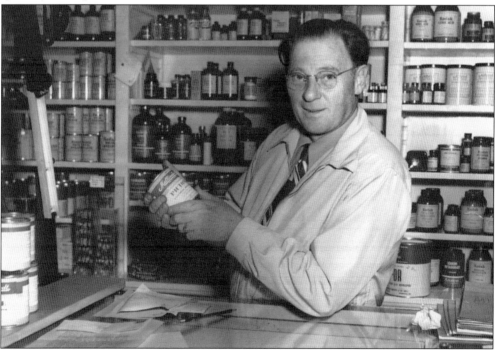

DONALD OTIS WEBB, 1960s. Posing here inside Webb's Photo Supply, a downtown San Jose institution for 50 years, Donald took over his father's business and expanded around the Bay Area not long after purchasing 829 Bird Avenue in 1926. At age 16, Donald had convinced the US Navy he was ready to fight in World War I—until his father found out and pulled his son off a submarine in San Francisco.

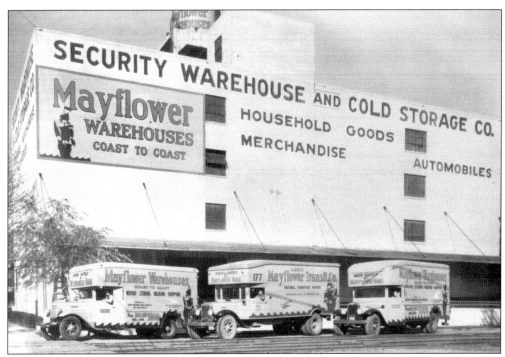

SECURITY WAREHOUSE AND COLD STORAGE, 1935. William Haley was an enterprising character with a wide range of interests. In 1904, the San Jose Court of Foresters of America made him chief ranger. In 1907, he requested license to take over the old Leddy saloon on Santa Clara Street and was later involved at Brassy & Company, a local liquor wholesaler. But by the 1930s, he was deputy superintendent at the Security Warehouse operation, and he built 821 Bird Avenue.

HAMLIN PACKING CRATES, 1920s.
In 1924, Edwin Hamlin purchased
779 Bird Avenue along with the land
where 645 and 655 Riverside Drive
would later be built in order to extend
Hartford Avenue to his property for
future development. Edwin had just
opened the Hamlin Packing Company,
and sons Homer and Howard worked
in the family business until they sold it
in 1929. Homer moved his family into
945 Plaza Drive in 1925. (Courtesy of
the San Jose State University Library
Special Collections Department, John
C. Gordon Photographic Collection.)

791 BIRD AVENUE, 1922. In 1919, Forrest and Robin Bruch took their three lots facing Riverside Drive and subdivided them into two lots facing Bird Avenue. They hired Albert Haskins to build 781 Bird Avenue for sale and 791 Bird Avenue for their family in 1920. The former was sold to William Tuttle, director of the Ruehl-Wheeler Nursery. (Courtesy of Rick Nelson.)

FORREST BRUCH, 1920s. Real estate man Forrest Bruch worked for San Jose's premier realty firm, T.S. Montgomery, until 1924. Then, he partnered with Palm Haven residents William Biebrach of 665 Coe Avenue and Arthur Moore of 915 Plaza Drive to buy out the old Montgomery firm and form Biebrach, Bruch & Moore. The Palm Haven firm maintained its dominance in San Jose real estate for many years. (Courtesy of Rick Nelson.)

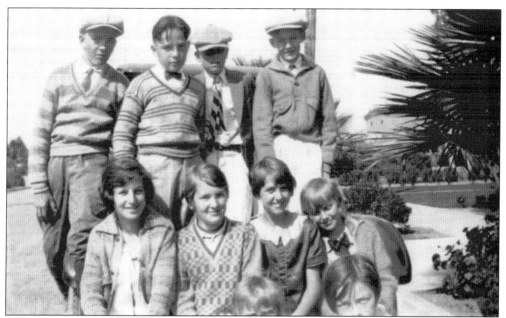

PALM HAVEN KIDS, 1926. With 791 Bird Avenue off camera to the right, this photograph was taken by someone facing west on Riverside Drive. Lynn Wolfe is in his characteristic swanky pose at the far left of the second row; his sister Claire is the second girl from left in the first row, followed by, left to right, Robin and Barbara Bruch. (Courtesy of Rick Nelson.)

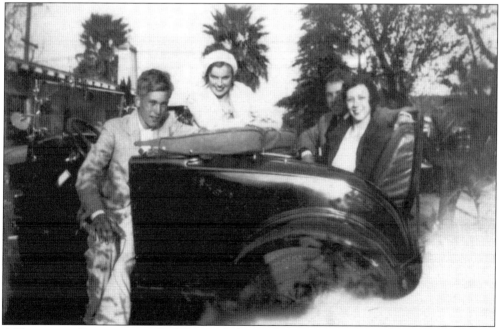

A TRIP TO THE BEACH, 1930s. Barbara Bruch, her unidentified boyfriend, and unidentified friends in the jump seat pose for a photograph in front of the Bruch home (background, left) before heading to Santa Cruz. Barbara obtained her doctorate in psychology from Stanford University and went on to work with children with disabilities, following in the footsteps of her grandfather, Louis Bruch, in children's education. (Courtesy of Rick Nelson.)

HENRY HOFF, 1914. Henry Hoff, the first president of the San Jose Rotary Club, purchased 625 Riverside Drive in 1926 and remained there with his wife, Tillie, for four years. He owned the Hoff-Keyser shoe business in downtown San Jose. A member of the Native Sons of the Golden West and urged by many to run for city council, Hoff was a very popular community booster, particularly in matters of sport. His baseball commentary was regularly quoted in the newspaper.

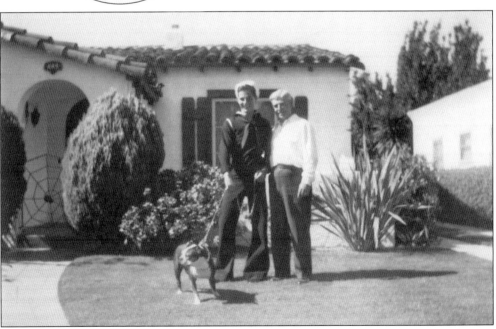

WALTER WYSOCK, JAMES "JIMMIE" HIGGINS, 645 RIVERSIDE DRIVE, 1942. James Higgins, a mechanical engineer for American Can Company and Navy veteran of World War I, purchased this home for himself and his wife, Gladys, in 1934 from builder August Calvelli. Higgins's nephew Walter Wysock became close friends with his Uncle Jimmie and Aunt Gladys. The charming spiderweb gate is gone and the windows to the courtyard have been changed to French doors, but otherwise the home retains its original appearance today. (Courtesy of Vicki Higgins.)

ANDREA (RIGHT) AND STEFANO D'ARRIGO, 1940s. Sicilian brothers Andrea and Stefano D'Arrigo immigrated to the United States in 1904 and 1911. They assimilated into the American culture, learned English, and changed their names to Andrew and Stephen. They worked odd jobs and, after going to school to obtain engineering degrees, fought in World War I. After the war, the brothers worked at a farmers market in Boston, Massachusetts; they later formed the vegetable business D'Arrigo Brothers Company of Massachusetts. On a wine grape–buying trip to the Santa Clara valley, Stephen noticed the ideal growing climate of the area and settled here in 1924 to form the D'Arrigo Brothers of San Jose. By the end of the year, his wife, Concetta, had given birth to their son Andrew, and Stephen had hired L.C. Rossi to build their family home at 815 Hartford Avenue. (Both, courtesy of the D'Arrigo Brothers Company of California.)

THE D'ARRIGOS VISIT WAWONA, 1920s. Broccoli was long a staple in the Italian diet, and the D'Arrigos would supply it to their respective Italian communities. But at that time, Americans only ate produce available locally and in season. Realizing he could sell the vegetable to easterners after their growing season ended, Stephen filled a railroad car with ice-packed broccoli and shipped it to his brother for sale in Boston. This experiment would revolutionize the produce industry. (Courtesy of the D'Arrigo Brothers Company of California.)

EVER SWEET LABEL, 1920s. After the D'Arrigos started their revolutionary transcontinental produce shipments, the rest of the industry realigned itself to do the same. This amplified the demand for California produce because of the state's long growing season. But the brothers noticed that grocers and distributors would take their quality product and stick their own labels on the crates. Their answer to this was to create a distinct label and wrap each bunch individually. (Courtesy of the D'Arrigo Brothers Company of California.)

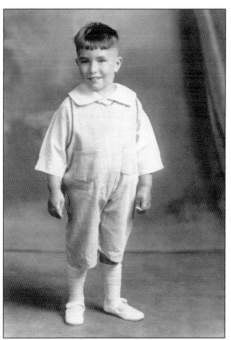

ANDY D'ARRIGO, 1926. Stephen chose the color pink to distinguish his labels from others. Then, he took a photograph of his son, put his face on the produce label, and trademarked the Andy Boy brand. Marketing history was made—it was the first-ever trademarked brand name used on a package of fresh produce. This is the original photograph. A face familiar in Palm Haven was sent across America and has been seen on millions of labels since. (Courtesy of the D'Arrigo Brothers Company of California.)

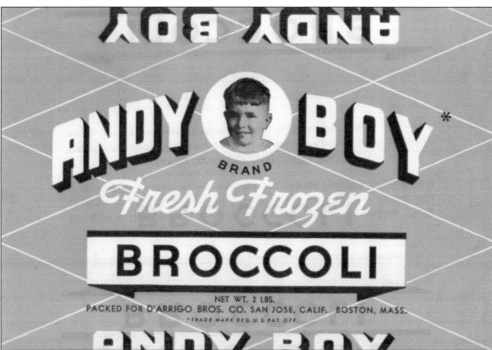

ORIGINAL ANDY BOY LABEL, 1927. Here is a trademarked label, which is pink with black-and-white lettering. The D'Arrigos wanted to share their love of broccoli, and they leveraged highly popular radio shows to reach the public by being the first branded vegetable sponsor and broadcasting cooking shows featuring the vegetable. For the first time, many Americans everywhere heard and learned about and started eating the company's broccoli. By 2010, Americans consumed 5.6 pounds of broccoli per person. (Courtesy of the D'Arrigo Brothers Company of California.)

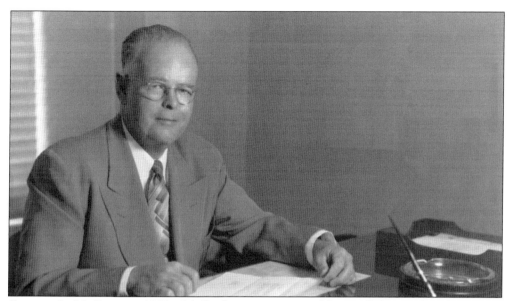

CHARLES L. MCCARTHY, 1940s. McCarthy was manager of Station Relations for NBC in San Francisco until 1934, when he and Ralph Brunton, part owner of KJBS in San Francisco, joined forces to purchase the San Jose radio station KQW. Within months, McCarthy left San Francisco and moved to 853 Hartford Avenue. However, they would consolidate studios in San Francisco, and in 1942 KQW became a CBS affiliate, with McCarthy becoming regional vice president for CBS. (Courtesy of John Schneider.)

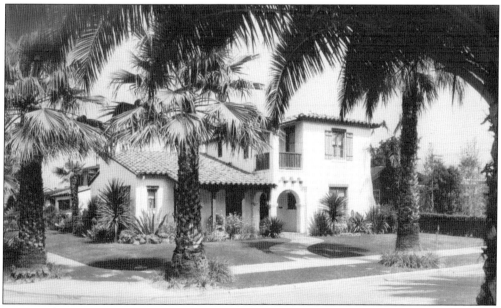

645 PALM HAVEN AVENUE, 1930s. This Wolfe & Higgins–designed residence was the final home Ernest Wolfe would build in Palm Haven. The stuccoed walls, arch details, and clay-tiled roof are at home in the Spanish Colonial Revival–style, but the design marks a pivotal shift toward the California Ranch style with its covered porch on wood posts and wraparound courtyard. The exterior retains its original appearance, excluding an added balconet and missing upper-window shutters. (Courtesy of the Wolfe family.)

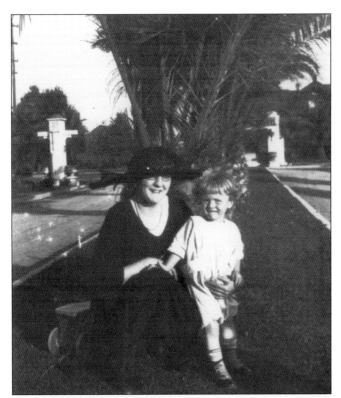

SOPHIE AND ROBERT KLEIN, c. 1921. This photograph was taken from the median that bisects Palm Haven Avenue toward the Bird Avenue entrance. A Mission Revival–style pillar can be seen, as can part of the trolley station. The two-story residence at right and across Bird Avenue is a Frank Wolfe–designed home for Producers Warehouse president Harry Lillick. Sophie, who owned a successful millinery in downtown San Jose for many years, most likely designed the hat she wears here. (Courtesy of Mariellen Klein.)

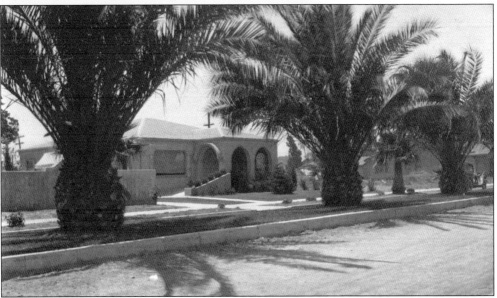

636 PALM HAVEN AVENUE, c. 1923. Herman Krause designed a two-story home for his good friends Adrian and Sophie Klein to be built in this location in 1920, but they chose to leave off the second story. While Sophie's stable downtown millinery remained a family business for many years, Adrian's interests were varied and often fanciful. According to the newspaper, he and Krause were nationally known scenic artists and locally celebrated parade float builders. (Courtesy of Mariellen Klein.)

THE BON-TON MILLINERY INTERIOR, 1920s. Sophie Klein's Bon-Ton Millinery was a fashion center for San Jose. Sophie would put on fashion shows at the Fox Theatre, where the "Bon-Ton Beauties" would take the stage to model ladies' wear while Adrian Klein played the theater organ. Adrian was involved in a number of other businesses over the years, including Rucker-Klein Limited realtors, wire-service photography, and automobile oil supplies. (Courtesy of Mariellen Klein.)

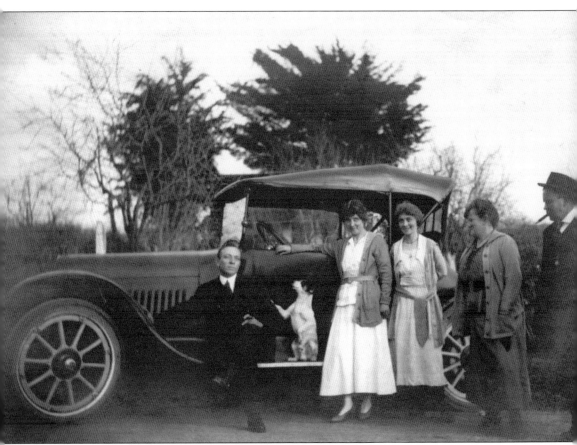

ADRIAN AND SOPHIE KLEIN AND FRIENDS, C. 1918. Adrian (far left) loved automobiles, and the family said he purchased a new sports car every year. Seeing young ladies drawn to her husband's natural charisma in his shiny new cars, Sophie (third from left) decreed that he could purchase a new vehicle every year but that, from then on, it would have to be a Cadillac. Adrian acquiesced, and Sophie continued the tradition after he died, hiring a chauffeur to drive the big automobiles. The couple is pictured here with three unidentified companions and a dog. (Courtesy of Mariellen Klein.)

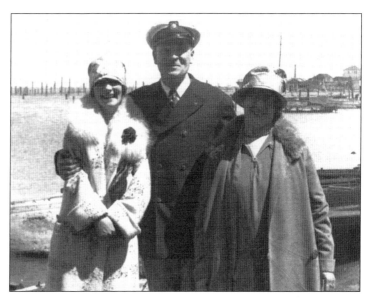

THE KLEINS (LEFT) AND AN UNIDENTIFIED FRIEND, 1920s. One of Adrian's many interests was yachting. He built a boat that he kept at the South Bay Yacht Club in Alviso (in background). Family lore holds that he maintained a still behind Mount Hamilton during Prohibition and kept production behind a heavy wooden door in his basement at 636 Palm Haven Avenue. (Courtesy of Mariellen Klein.)

BLOOM L. SONS COMPANY, INC., 1920s. In 1925, Adrian Klein had 644 and 650 Palm Haven Avenue built. He sold 650 and kept 644, adjacent to his home, as a rental property until he could give it to his son Robert. Grace Bouckout was already working at Sophie Klein's millinery, while her husband, John, was a window trimmer at Bloom's (pictured here) in downtown San Jose. The Kleins let them stay at 650 Palm Haven for a couple of years.

RICHMOND-CHASE PLANT No. 7, 1920s. George Eldridge purchased 656 Palm Haven Avenue in 1923. He was the plant superintendent for the large fruit-processing company Richmond-Chase. Having built the industry's most advanced processing plants, the company enjoyed great success during the 1920s and 1930s when San Jose had become the fruit-processing center of the world.

RICHMOND-CHASE PROCESSING PLANT, 1920s. This photograph illustrates the sophistication of the Richmond-Chase Company's fruit-processing operation. The firm had invented machinery to do mundane tasks like coring or slicing fruit on a massive scale but still required people in some capacities. Here, women monitor the output of a slicer before the next stage in processing.

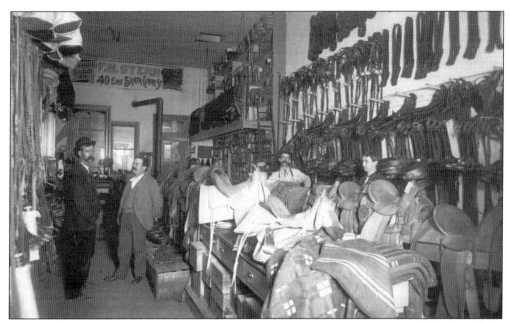

F.M. Stern Harness Shop Interior, 1898. In 1852, German immigrant Marcus Stern opened a saddlery in San Jose and quickly became involved in civic affairs. A devout Jew, Stern helped establish San Jose's first synagogue and the Hebrew Society called Bickur Cholim. His son Fred (second from left) continued the business under his name. Fred's son Harold had 666 Palm Haven Avenue built in 1925 and also continued the business.

F.M. Stern Cowboy Catalog, c. 1900. Stern's saddlery quickly developed a reputation for the finest-quality handmade saddle goods and employed the best bit and spur makers in the business, which allowed them to export product well beyond the San Jose area. When Harold took over the family business, he kept the well-regarded name but added ladies' leather goods and luggage and expanded the company with stores all over California.

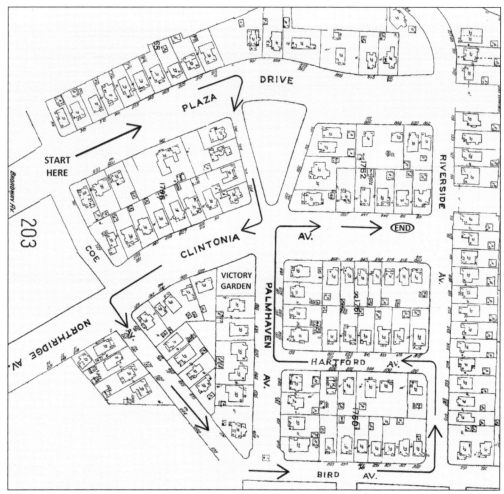

WALKING TOUR OF POLITICAL AND COMMUNITY LEADERS. As seen in the Sanborn Fire Insurance map on page 38, most of Palm Haven had been developed by 1950, save a few lots. But the arrows on this version of the map follow the text in the next section for a walking tour of Palm Haven's numerous community leaders' homes. Some of these individuals owned businesses that have already been mentioned while also serving the community by taking publicly elected positions in local government. Others made government service a lifetime occupation. A number of religious leaders also made their homes in Palm Haven. Many took their turns in holding official positions in the Palm Haven Tract Association to guide the affairs of their little independent "city." A desire to better the world, both locally and abroad, seemed to be coursing through the veins of many Palm Haven residents. They not only wanted to take their own journeys, they often wanted to take others with them. San Jose had no idea it was about to see its locus of power shift southwest to Palm Haven. (Courtesy of Michael Borbely.)

ON THE STEPS OF CITY HALL, 1920s. Palm Haven's involvement in city government can be partly seen in this photograph of San Jose city staff. At top left, looking away, is city manager Clarence Goodwin. Standing at rear, fourth from the right in a hat, glasses, and fluffy collar, is the eminent poet, author, and city head librarian Edith Daley. And standing at the far right in a bow tie is police judge Percy O'Connor.

POLICE COURTROOM, CITY HALL, 1920s. Long before *Judge Judy* and other courtroom television shows, Palm Haven resident and police judge Percy O'Connor created the *Traffic Court of the Air* in 1935 and broadcast it from his court in San Jose's city hall every Monday afternoon. The weekly radio broadcast was wildly popular and gained vast audiences on the West Coast.

PERCY O'CONNOR, 1920s. Elected San Jose's police judge in 1924, Percy O'Connor was an atypical magistrate. His photogenic and charismatic qualities earned him regular newspaper coverage on matters that had nothing to do with his office. He was a highly sought-after emcee, and "O'Connor to Preside as Master of Ceremonies" was a frequent newspaper headline. His lock on popularity secured his judgeship for over 20 years. In 1925, the O'Connors had 970 Plaza Drive built for their growing family. (Courtesy of Colleen O'Connor.)

DORIS O'CONNOR IN FRONT OF 970 PLAZA DRIVE, 1952. This photograph was taken for a newspaper feature on "Mrs. O.C." and her years as the wife of San Jose's popular municipal judge while maintaining a household of all boys. Doris matched her husband's public life by leading numerous civic organizations for many years. At their Palm Haven home, their frequent social gatherings were always newsworthy and served to bolster Doris's reputation as the consummate homemaker. (Courtesy of Colleen O'Connor.)

JOHN DERROL CHACE, 1947. Next door to the O'Connor residence was the Chace place at 960 Plaza Drive. A Stanford graduate and star athlete, John Chace served meritoriously in World War I and returned to become a prominent San Jose businessman while accumulating real estate like his father. He and his wife, Louise, often hosted San Jose's gentry at their La Casa De Tres Juans estate in Monterey.

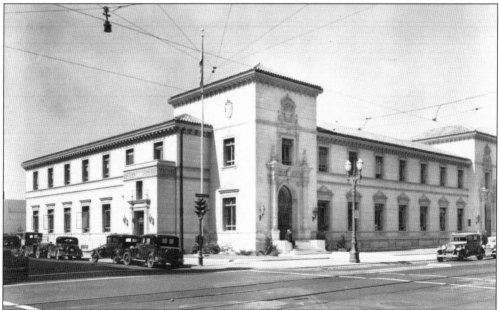

SAN JOSE MAIN POST OFFICE, 1930S. Now in the National Register of Historic Places, this Ralph Wyckoff–designed Spanish Colonial Revival edifice opened in 1933 as San Jose's main post office. John D. Chace's father had been San Jose's postmaster since 1912, but upon his death in 1931, John took his father's place as acting postmaster. In 1932, Pres. Herbert Hoover personally recommended he fill the post permanently, and so he did through 1936.

L. D. BOHNETT

⇒FOR⇐

Member of

CONGRESS

Eighth District

San Jose Post Print

Lewis Dan "L.D." Bohnett, 1914. The political endeavors of L.D. are many. This image is from his run as a Progressive in the Eighth Congressional District, which he lost. No matter, he had a history of staring down opposition. Upon being elected as editor of the student-run *Daily Californian* while studying at Berkeley, he used his post to criticize various students' wrongdoings. He lambasted those who allegedly stole magazines from the library and posited that if Cato's proclamation "Carthago delenda est" ("Carthage must be destroyed") could bring about the destruction of that city, then perhaps repeating "Women's hats must go!" would lead to female students removing their large hats while in class. He finally burned away his support when he rearranged newspaper duties, creating heavy workloads for the volunteer staff. When asked to reconsider, he said the staff was lazy. They called him a "czar journalist" and threatened to walk out, and the university had to step in to quell the matter. After Bohnett graduated, he returned to San Jose and became deputy county clerk before serving three terms as the California State Assembly floor leader for Gov. Hiram Johnson. He introduced numerous progressive reforms during this period, including railroad regulations and workers' compensation laws. He was just warming up. (Courtesy of Barbara L. Bohnett.)

Bank of San Jose Building, 1930s. Outside of his Progressive Party involvement, L.D. Bohnett was a Republican and ran a successful law practice, Bohnett & Hill, in offices at the "Beans Building" (shown here). He began speculating in real estate and purchased numerous lots in Palm Haven as investments. After briefly living in a couple of Palm Haven homes, he seized the opportunity to purchase 940 Plaza Drive in 1923. He and his wife, Ivadelle, raised their two boys there and lived there until their deaths. L.D. was behind the development of many Palm Haven properties as a director of the Palm Haven Investment Company, and he hired his father-in-law, Edgar Bevens, to erect several homes on lots he owned. Bohnett became the Palm Haven Tract Association's first president in 1917 and would become its de facto legal counsel against an old foe he faced several years earlier—the Southern Pacific Railroad. In 2008, L.D.'s eldest granddaughter, Joan E. Bohnett, had her grandparents' home designated a San Jose City Landmark.

ELLEN TRAINOR BEVENS AND JOHN BOHNETT, 1925. On John's 11th birthday, his grandmother Bevens knew what would hit the spot. Ellen and husband Edgar lived close by at 655 Palm Haven Avenue. John would follow in his father's footsteps by obtaining a law degree from the University of California at Berkeley and becoming a full partner in the Bohnett law firm for 46 years. (Courtesy of Barbara L. Bohnett.)

PALM HAVEN KIDS HANG OUT, c. 1931. Pictured here are Lewis Dan Bohnett Jr. (sitting on the running board wearing a beanie) and, from left to right, John Bohnett, Lynn Wolfe, Leo Worrell, and June Bevens. Part of 722 Palm Haven Avenue can be seen behind John, and 940 Plaza Drive is behind June. A 680 Coe Avenue resident, Worrell grew up with the rest of the Palm Haven kids as friends.

Lewis Dan Bohnett Jr. (Right) and Unidentified Friend, 1930s. L.D. Bohnett's younger son, Lewis Dan "Ding" Bohnett, had a penchant for collecting things. Here, he has what appears to be an old wagon hearse loaded on a trailer and ready to go. Ding would later open the amusement park Trader Lew's off Monterey Road in San Jose. One day, he would turn over his sizable collection of artifacts to the city for a future historical museum.

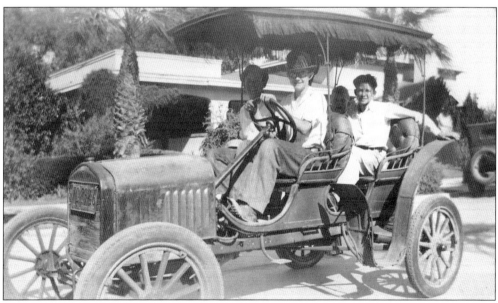

Lewis Dan Bohnett Jr. Driving Friends, 1930s. As soon as L.D. Jr. was old enough to drive, he loved finding old jalopies and carting around his friends in them, as can be seen in this photograph. In the background, the Bohnett family home, 940 Plaza Drive, still has the original parapet around the porte cochere roof in this photograph. This architectural feature was removed in the 1990s.

THE MERCURY HERALD OFFICES, C. 1920. Charles Sumner Allen arrived in the first wave of Palm Haven's development at 901 Plaza Drive, but his civic dedication was an enduring face of Palm Haven influence in the San Jose area and far beyond. He was a close personal friend of US president Herbert Hoover and helped with draft board work for World War I. He presided over the San Jose Board of Education for 24 years and was the chief editorial writer for the *San Jose Mercury Herald* for 10 years. He was also president of numerous civic organizations, and his commendations were plenty, but perhaps one of his most important impacts on local history was convincing his former law partner Paul Clark to move to San Jose from Nebraska. Clark and his wife, May, first moved to nearby 571 Coe Avenue before hiring Frank Wolfe to design a Prairie-style home like Allen's on Minnesota Avenue, to the south in "the Willows." "Retired" Clark would become the first mayor of Willow Glen.

SAN JOSE ABSTRACT COMPANY HEAD, 1900S. Cornelius Pitman had 722 Palm Haven Avenue built in 1917. Pitman was born on the site of today's Stanford University football stadium in 1859, and his father owned farmland that later became Palo Alto's commercial district. After leaving the farm, he and his brother ran the San Jose Abstract Company for several years. In 1914, Pitman was elected Santa Clara County assessor, a post he held until his death in 1934.

FORMER HOME OF BENEVOLENCE, RECENT. A James Lick grant helped build this structure in 1924. Widow Lydia Toland McKee purchased 704 Palm Haven Avenue in 1930 for her retirement. She inspired many with her involvement in numerous civic organizations but was most remembered for leading the Home of Benevolence, organized in 1867 to care for homeless children. She was made president emeritus after she retired from 28 years of service. (Courtesy of Michael Borbely.)

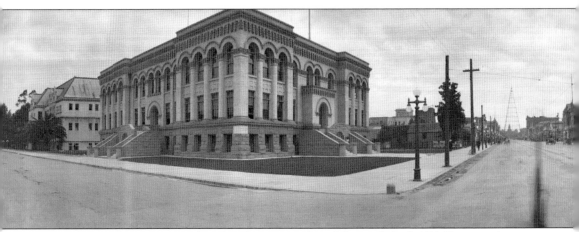

HALL OF JUSTICE, 1900s. Urban Sontheimer purchased the newly built 927 Clintonia Avenue in 1924. A Stanford University law graduate, Sontheimer opened a law practice in San Jose in 1914. He held court at the Hall of Justice as justice of the peace of San Jose for 10 years, and he and his brother Walter founded the Guaranty Building & Loan Association. Today, the Urban A. Sontheimer Award is given to outstanding Stanford law students. (Courtesy of the San Jose State University Library Special Collections Department, John C. Gordon Photographic Collection.)

WILLIAM L. BIEBRACH, 1930. Already a successful downtown San Jose merchant and living at 665 Coe Avenue, Biebrach became the senior partner in the real estate firm Biebrach, Bruch & Moore. He was president of numerous business and civic organizations and became the 40th mayor of the city of San Jose in 1930 in addition to his service on council for 12 years.

SAN JOSE CITY COUNCIL, 1939. William Biebrach is seated at the council table second from right, while city manager Clarence Goodwin is seated at the left corner of the mayor's bench in rear. Biebrach had already been mayor seven years, but his civic commitment continued until his sudden death from an illness in 1943. Shortly afterward, a mourning San Jose dedicated Biebrach Park near Palm Haven on Virginia and Delmas Avenues.

JOHN MCENERY STANDS LEFT OF ELEANOR ROOSEVELT (IN BLACK DRESS AND HAT), 1940. Before John McEnery set up his Ayer Avenue family home in San Jose, he and his wife, Margaret, lived at 865 Bird Avenue. A member of the Truman administration and chairman of the California Democratic Party, "Big John" was an early supporter and confidant of John F. Kennedy. In this photograph, he introduces Eleanor Roosevelt to the Democratic Party at the Hotel DeAnza. A park in downtown San Jose bears McEnery's name.

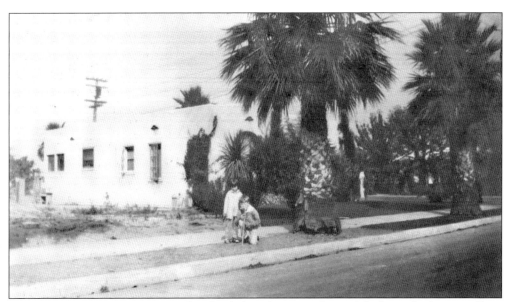

809 Bird Avenue, 1931. Ann and Ted Whelan play out in front of the house built originally in 1925 for William and Mabel Case. The original property included the adjacent lot. William was a Presbyterian minister, and his wife was active in the Young Women's Christian Association as its general secretary. William was transferred to another church outside San Jose soon after they moved into Palm Haven. (Courtesy of Mariellen Klein.)

Church of the Five Wounds, 1939. The local parish of the Portuguese church was established in 1914 in a small chapel, but in 1919 this impressive church—a copy of one in Braga, Portugal—was built in San Jose. Fr. John Ferdinand moved into 853 Hartford Avenue in 1924 and remained until 1927 when he was transferred to another parish.

MARCUS STERN, EARLY 1900S. As previously mentioned, Harold Stern's grandfather Marcus was an early San Jose civic leader, businessman, and devout Jew. He helped establish the city's first Hebrew society and, later, the Congregation Bickur Cholim. In 1870, the congregation built the first Jewish synagogue in the area in downtown San Jose. Families from as far as San Francisco and San Juan Bautista traveled by wagon to attend services.

BICKUR CHOLIM SYNAGOGUE, EARLY 1900S. When Harvey Franklin became rabbi for the synagogue in 1921, he moved in with lifelong friend Townsend Nichols at 847 Clintonia Avenue. He remained rabbi until 1931, adding services for both Reform and Orthodox congregations. The synagogue burned in a 1940 fire, and the congregation—now Temple Emanu-El—built a new temple on University Avenue in San Jose. (Courtesy of the San Jose State University Library Special Collections Department, John C. Gordon Photographic Collection.)

CLARENCE GOODWIN, 1920s.
Clarence Goodwin hired Herman
Krause to design his home at 815
Clintonia Avenue in 1923. In 1916,
the San Jose city charter made
its mayor essentially an honorary
title conferred by the council and
vested all authority in a council-
appointed city manager—a role
Goodwin held from 1920 to 1944.
While the council held political
forum, Goodwin effectively
ran city hall. Elected mayoral
authority was restored in 1967.

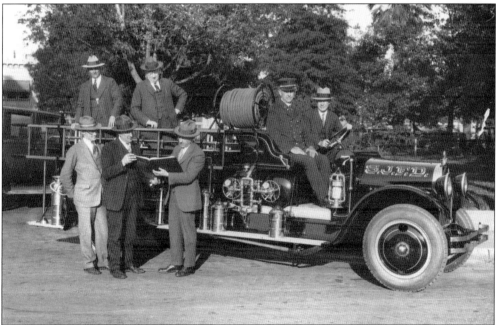

CHEMICAL NO. 7, 1926. Posing here for a newspaper photograph, city officials show off a new fire engine. Clarence Goodwin is holding the book. By 1930, in the middle of the railroad controversy (see pages 114–115), Goodwin moved into nearby 863 Riverside Drive and remained there until 1944, when his two-decade reign at city hall had finally come to an end.

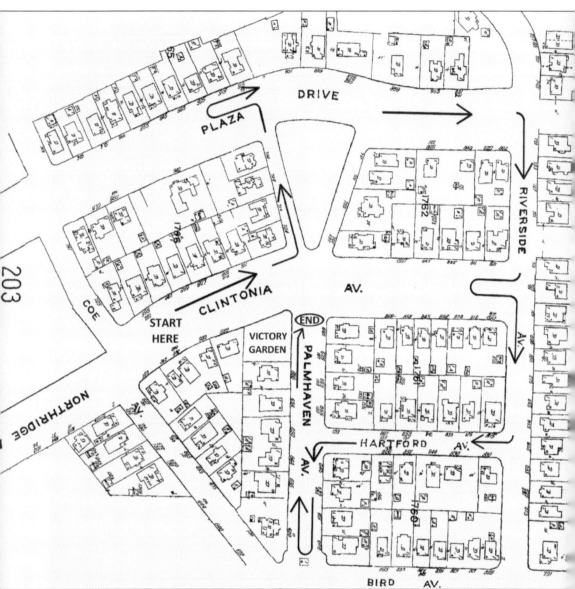

WALKING TOUR OF ARTISTS AND AUTHORS, ARCHITECTS, AND OTHERS. In a 2011 interview, a new Palm Haven resident remarked that when he first toured the neighborhood, "It seemed like maybe artists live here." His perspicacious statement could well be traced to a number of artists and creative residents in recent years, and some are mentioned in chapter four. But Palm Haven's independent status in the early 1900s and perhaps its refined streetscape appealed to persons seeking inspiration and freedom from the status quo. As is the case with other sections of this book, there were other residents who exemplified the Palm Haven spirit but could not be included for a variety of reasons. This, the shortest of the walking tours, reviews Palm Haven's early creative set, beginning with a real estate man who invented radio electronics devices. Others invented concrete blocks used in construction, pumps, and other devices used in the fruit canning industry. Creative talents like Lysle Bush or Adrian and Sophie Klein successfully leveraged their creative talents in business and should be counted here as well. Creativity in Palm Haven came as one might expect: diverse and unexpected. (Courtesy of Michael Borbely.)

RADIO TUNER PATENT DRAWING, 1942. This patent was filed in 1928 by William L. Jacke when he was living at 936 Clintonia Avenue. Jacke was a real estate salesman when he moved to Palm Haven in 1924, but as an inventor he was able to sell his patent on an automatic radio tuner to the Philco radio company. He later obtained a patent on a clock radio unit that would turn on different stations at different times. (Courtesy of Michael Borbely.)

CHARLES MCKENZIE, C. 1913. Charles McKenzie, a former partner with Frank Wolfe and one of San Jose's premier architects, designed 925 Clintonia Avenue in 1913. In 1921, he redesigned 722 Palm Haven Avenue for Frank Giorza King and his wife, Alice. King (son of the late F. Loui King, who founded the King Conservatory of Music) was an accomplished pianist and had McKenzie design the front room for his piano.

722 PALM HAVEN AVENUE, 2002. Frank King's father, an accomplished musician, composer, and teacher from England, was convinced he could elevate San Jose's musical standards to make it the greatest center for classical music in America. His passion and efforts produced results: students were coming from states across the west and later received glowing reports from European graduate schools. Frank followed in his father's footsteps for a while but later settled into real estate. (Courtesy of Michael Borbely.)

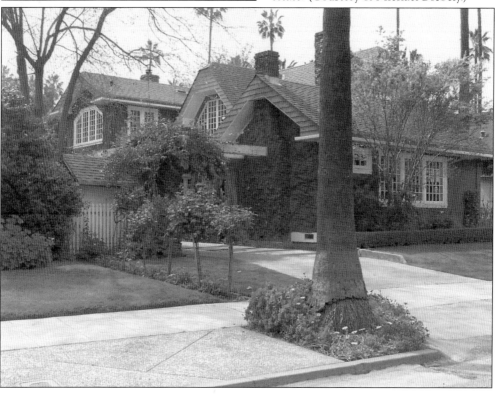

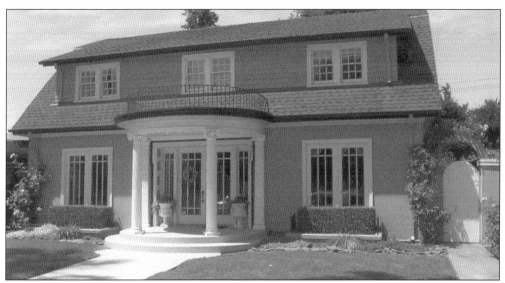

925 Plaza Drive, 2004. The conservative design of Frank Wolfe's last home masks his innovations. Like Frank Lloyd Wright's Stockman House, the structure's first-floor walls were cast in concrete, but Wolfe also incorporated radiant floor heating. Wright has received credit for being the first to use the technology in a residence, but that credit may be due Wolfe since this house predates the Wright example by 16 years.

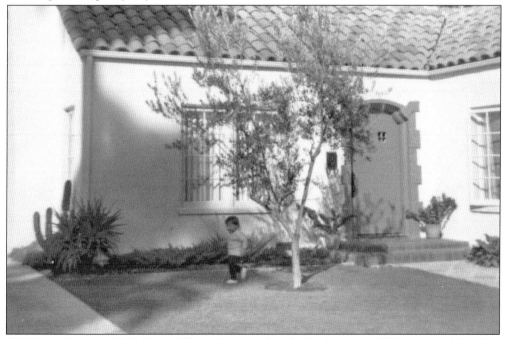

821 Plaza Drive, 1966. Frank Pfister Schemmel built this house in 1925 for himself and his wife, Gladys. Frank's father, Henry, immigrated from Germany an accomplished musician and soon organized San Jose's first orchestra, the San Jose Orchestral Society. He opened Schemmel's Music House, and Frank learned to play violin attending the King Conservatory of Music. Frank's mother was a Pfister, a member of the well-known German pioneer family. Frank had both business and creative interests. (Courtesy of Norvelle Benevento.)

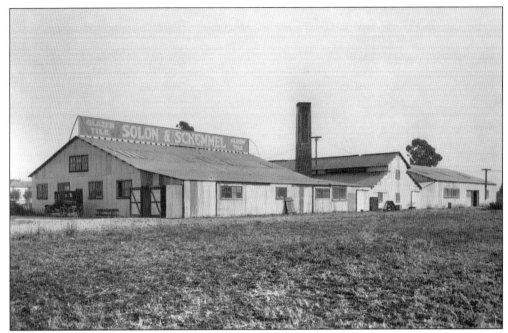

SOLON & SCHEMMEL FACTORY, 1920S. Frank Schemmel was introduced to tile maker Albert Solon by architect Ernie Curtis, and the two formed a tile company and began producing highly acclaimed tile work. Solon is credited with the creative side of the business, but Schemmel's wife said in a 1992 interview that Frank designed tiles as well. Today, their work can be found at important historical sites in California, including many residences in Palm Haven. (Courtesy of the San Jose State University Library Special Collections Department, John C. Gordon Photographic Collection.)

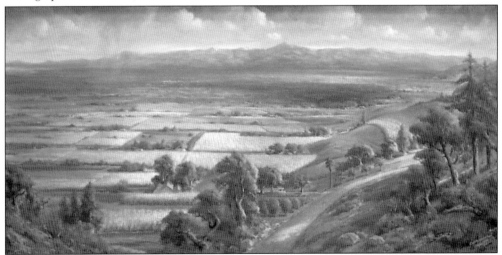

BLOSSOM TIME IN EAST SANTA CLARA VALLEY, 1915. In 1925, Charles and Ida Harmon purchased 815 Clintonia Avenue. By the turn of the 20th century, three painters dominated the local scene: Charles Harmon, Andrew Hill, and Astley Cooper. Harmon died in his Clintonia home in 1936, but his paintings continue to garner wide acclaim. He was commissioned to do this painting for the 1915 San Francisco World's Fair, and today it hangs in the Santa Clara County Courthouse. (Courtesy of Michael Borbely.)

BLAND, DALEY, AND MARKHAM, 1929.
Edith Daley, while head librarian for San
Jose, was an accomplished writer and poet
who was close personal friends with poet/
philosopher/teacher Henry Meade Bland
(left) and nationally acclaimed poet Edwin
Markham (right). "The Three Poets," as
they were called, are gathered at 633 Palm
Haven Avenue on this occasion to celebrate
Bland's new appointment as California's poet
laureate. Bland wrote the foreword to Daley's
1917 book of poems *The Angel in the Sun*.

EDWIN MARKHAM, 1929. Markham, an 1872
graduate of San Jose State Normal School,
had published his seminal work, *The Man
with the Hoe and Other Poems*, by 1899. He
lived in San Jose for a time, and Edith Daley
developed a lasting friendship with him.
Here, Markham stands at the courtyard
entrance to Daley's Palm Haven home.

600 Palm Haven Avenue, 1923. This photograph was taken for a newspaper article titled "The Artistic Home of Herman Krause," which describes it as being of the Italian Renaissance style but "stripped of the bizarre effects of this period." Indeed, this home has little in common with the Italian Renaissance Revival style save its stucco walls and a couple of arches. Its eclectic, Californian style displays modernist influences that emphasized form over ornament and, in this particular case, a clear response to the unusual triangular building site. Krause, a San Jose native, started as a poster and sign painter for San Jose's busy downtown but was soon remodeling storefronts and then houses for his business clients. He built this home in 1919 just as he was establishing his own architectural design business. The interior is a showcase of his design talents, and the structure proudly sits at Palm Haven's most visible entrance. Krause invited guests to enjoy the sunken gardens and dance in his second-story ballroom. The home was restored in 2000 with additions on its west side. (Courtesy of the San Jose State University Library Special Collections Department, John C. Gordon Photographic Collection.)

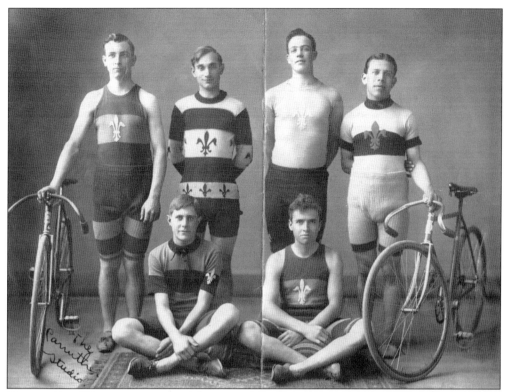

GARDEN CITY WHEELMEN, C. 1910. The young fellow standing second from left is Howard Waltz, a winning racer who later built 600 Palm Haven Avenue. After his racing days, Waltz worked for Frank Wolfe as an architectural draftsman for six years. He later developed a reputable construction business that built many expensive homes for wealthy local clients.

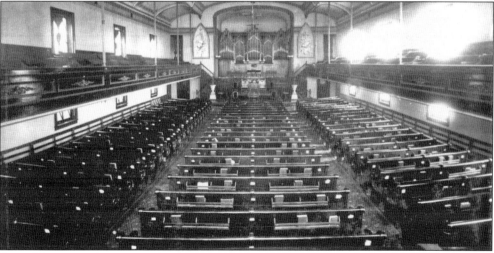

FIRST METHODIST EPISCOPAL CHURCH, 1910s. Brothers Claude and Clarence Argall lived at 656 Palm Haven Avenue in 1922. They and their brothers Charles and Donald formed a popular singing quartet before World War I. They entertained the troops while at war and, when they returned, had received offers to tour nationally and produce a record. In 1917, the "Argall Boys" gave a farewell concert in this auditorium to a packed crowd.

SANTA CLARA STREET AT FOURTH STREET RAIL CROSSING, 1935. Captured just before the opening of San Jose's new main rail depot, this was a typical scene downtown. Early railroads came right through towns for convenience, but as the allure of the train receded in the wake of the automobile, the noise, pollution, and traffic-clogging movement caused by trains led cities to want to move them off to the sides of their downtowns. The terms "railroad job" and being "railroaded" were already in the American lexicon as railroad barons of the late 19th century forced property owners to comply with their wishes. The stories of extortion, payoffs, and graft were well known, and the Southern Pacific Railroad had a grip on the California State Legislature to ensure it got what it wanted. But by 1918, L.D. Bohnett and Charles Allen were already attending railroad commission hearings because the Southern Pacific had proposed a new route, splitting the community of Willow Glen and backing up to Palm Haven.

Four

DEFINING A HERITAGE
RAILROAD BATTLE AND LATTER YEARS

Reside in Palm Haven and you will always lead.

—Arthur D. Shaw, San Jose realtor

As noted on page 114, Palm Haven was faced with the prospect of being "railroaded." Attorneys L.D. Bohnett and Charles Allen felt otherwise. Allen's friend and former law partner Paul Clark, a political progressive, was in good company with Bohnett. "One Sunday morning a group of us got together to see how we could prevent the railroad from going through as proposed," Bohnett recalls in a 1965 interview in the *Sun Times*.

The men's strategy was to help Willow Glen, which would feel the brunt of the Southern Pacific plan, to incorporate and force the railroad to request a franchise. They obtained the signatures needed to hold an election, and the people voted to incorporate into the City of Willow Glen in 1927, with Paul Clark as the first mayor and Bohnett as the attorney.

Willow Glen denied the franchise, so the railroad attempted to get the franchise law repealed while simultaneously building tracks anyway. Willow Glen took Southern Pacific to court and the case eventually made it to the US Supreme Court in 1931. The high court ruled on a procedural matter favoring the railroad whereupon Willow Glen vowed to file another lawsuit. Concerned the case could set a precedent for cities throughout California, the League of California Municipalities offered Bohnett support. But by 1931, the Great Depression changed the battle's dynamics: money was scarce but construction costs much lower. The railroad installed a new president from Bohnett's former stomping ground—the Oakland-Berkeley area—and struck a deal that included safer crossings and an improved route. It was a taxing battle, but it ensured that Palm Haven and Willow Glen would be what they are today.

Other important local figures emerged from Palm Haven over the years, though with less frequency than from the days when it was an independent city. However, a new spirit of independence has emerged as residents are taking interest in preserving the historic neighborhood. As one recent San Jose city official put it, "We at city hall have grown used to the fact that Palm Haven is going to do what it wants."

Indeed.

View Looking North on Plaza Drive, 1930s. In 1931, the newspaper, having strongly sided with San Jose and the railroad, had become thoroughly upset with Palm Haven's powerful grip on the railroad matter. It was taking shots at the neighborhood and published an article suggesting truck drivers were confused over entrance signs restricting hauling to local delivery. The closing quote reads, "There shouldn't be any problem in finding out definitely. We've got President Bill Biebrach of the council, City Manager Goodwin, Judge Percy O'Connor, and Policeman Jim Cunningham living out here in Palm Haven."

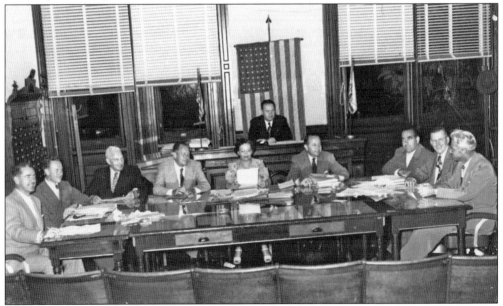

San Jose City Council Session, 1951. Palm Haven lost two big voices in the city with Clarence Goodwin's resignation in 1944 and William Biebrach's untimely death in 1943. But a new face had emerged in local business circles, and in 1946, Parker Hathaway of 802 Plaza Drive won a seat on city council. He can be seen here, smiling, second from right. Hathaway would remain on the council for 18 years.

PARKER HATHAWAY AND GYPSY, 1954. In 1952, Hathaway became San Jose's 51st mayor and second Palm Haven man to fill the city's most visible job. Well regarded by his peers, he presided over a productive and relatively peaceful council during his term. In this promotional photograph for the movie *Gypsy Colt*, Hathaway offers Gypsy the key to the city in front of city hall.

LORRY ?, EBONY, AND ZINA LOU HATHAWAY, 1944. Parker raised Zina Lou (right) and his family in this modest Spanish Colonial Revival bungalow at 802 Plaza Drive. In 1941, Parker was stricken with polio and confined to his bed for four months. The experience inspired him to take an active role in supporting the March of Dimes for 35 years. While the Hathaway house was extensively remodeled in 2009 in the Mission Revival style, it retains its original front arched windows, seen here. Zina Lou's friend Lorry holds Ebony. (Courtesy of Zina Lou Hathaway.)

PARKER HATHAWAY, NORVELLE BENEVENTO, 1957. Just across the street from the Hathaways, Norvelle was preparing to marry into the Tranchina family, part of a new generation of Palm Haven residents. This photograph was taken in the living room of Norvelle's mother's home at 721 Riverside Drive. Norvelle and Zina Lou Hathaway were good friends and remain so today. (Courtesy of Norvelle Benevento.)

WEDDING RECEPTION, 1957. The wedding reception of Norvelle and Joseph Tranchina was held at Norvelle's mother's Palm Haven dream home in May 1957. Some wedding photographs are forgettable, but others truly stand out. In this one, the gentlemen compete for the garter with absolute gusto. (Courtesy of Norvelle Benevento.)

821 Plaza Drive, 1970. Norvelle Benevento moved into this house just around the corner from her mother's home. Continuing a tradition of community service, Norvelle became the top secretary to the San Jose City Manager. In true Ortega dedication, she remained in that role through six different managers, from 1955 until her retirement in 1998. Her position gave her a "front-row" view into city politics. (Courtesy of Norvelle Benevento.)

San Martin Presbyterian Church, Recent. Col. Edward L. Trett purchased 725 Palm Haven Avenue after being discharged from the service in 1946 as an Army chaplain. He remained there until his death in 1977. While in San Jose, Trett served as pastor of the Presbyterian church in San Martin, a small town south of San Jose. The singular structure built in 1904 was designed by noted local architect William Binder. (Courtesy of Michael Borbely.)

LYDIA AND DONALD GRIFFIN, C. 1943. Standing with his mother in front of the same palm tree where he posed as a child (page 24), Donald Griffin was a true Palm Haven native son. He went to local schools and studied engineering at San Jose State College. When this photograph was taken, he had just enlisted in the US Marine Corps and was about to be sent to the Pacific theater, where he would make military history. (Courtesy of Nancy O'Sullivan.)

THE AMERICAN MAGAZINE, 1945. Donald Griffin saw plenty of war action and is featured in this magazine about America's men in service. Upon declassification, news wires broadcast one of Griffin's courageous missions. He and two others were sent to Iwo Jima to sketch pillboxes, caves, and gun emplacements. The team faced Japanese mortar, sniper fire, and machine guns churning the area all around while they drafted the layout, and Griffin earned numerous commendations for his service. (Courtesy of Nancy O'Sullivan.)

IN THE SERVICE OF THE NATION

THE American MAGAZINE · 25 CENTS · 30 CENTS IN CANADA

STREAMLINING CONGRESS by James F. Byrnes
WARTIME ASSISTANT PRESIDENT
COMPLETE NOVELS BY BOOTH TARKINGTON AND HUGH PENTECOST

LEVIN RICHMOND TERMINAL CORPORATION, RECENT. In 1939, when Richard Levin moved into 835 Clintonia Avenue, he and his brother David pooled $1,000 each to found the Levin Machinery and Salvage Company. Initially selling government-surplus hardware to the agricultural industry, the men grew the business to sell scrap metals, adding ports, ships, and the Richmond-Pacific Railroad to the operation. In 1988, Richard sold the scrap business, retaining the railroad and the Levin Richmond Terminal, today under the leadership of Gary Levin, Richard's grandson.

SAN JOSE AIRPORT GROUND BREAKING, 1948. In this photograph, San Jose city councilmen and Paul Birmingham (third from right, in dark suit) view and pose for the momentous ground breaking for San Jose's main airport. While Birmingham, an airport engineer, was living at 928 Clintonia Avenue from 1940 to 1952, he was responsible for planning San Jose's air-travel future. Many accolades were paid Birmingham for developing and managing the entire airport project for the city.

SAN JOSE MERCURY AND NEWS SIGN, 1960s. Workers in this photograph are readying "the world" for the newspaper. In 1978, David Yarnold began working for the *Mercury and News* and eventually became the award-winning paper's editor and vice president. Living at 995 Clintonia Avenue, Yarnold remained until 2010, when he moved to New York, becoming president of the National Audubon Society.

PALM HAVEN AVENUE ORIGINAL ENTRANCE, 1955. This photograph shows 600 Palm Haven Avenue at far left behind the large tree as well as the arched porch opening of 636 Palm Haven Avenue farther down the street. The pillar urns are missing their bowls. This main entrance to Palm Haven was closed years later when Bird Avenue was widened to keep the heavy traffic from using the neighborhood as an overflow route. (Courtesy of Michael Borbely.)

CRYSTAL CREAMERY, 1940s. Just before World War II, Peter and John Paul Aiello (who Anglicized their surname to Allen) purchased a three-restaurant chain in San Jose called Crystal Creamery. John took this one on Twelfth Street and served burgers and shakes for a while, but started adding his favorite Italian dishes after the war. With pizza added to the menu, he renamed the business Shakey Jake's, making it a very popular San Jose eatery. (Courtesy of Carolyn Allen.)

JOHN PAUL ALLEN (LEFT) AND JOE DIMAGGIO, 1960s. In 1958, John's Italian restaurant had come into its own and he gave it a new (and his middle name), Paolo's. John was the consummate restaurateur, always entertaining his guests and developing lifelong friendships. He regularly hosted celebrities and had become close friends with baseball great Joe DiMaggio. John's daughter Carolyn moved to Palm Haven in 1983 and has taken over the family business, operating the upscale restaurant with her husband, Jalil, in downtown San Jose. (Courtesy of Carolyn Allen.)

RIM ROCK, C. 2008. Upon receiving his master's degree in fine arts from San Jose State University in 1983, Ken Matsumoto began a long and successful career sculpting in natural stone, concrete, bronze, and other materials. About the same time, he and his wife, Joy, moved to 676 Palm Haven Avenue, then a single-story ranch-style home, but recently remodeled in the Second Bay Tradition style. (Courtesy of Ken Matsumoto.)

ART OBJECT GALLERY STUDIO, KEN MATSUMOTO, 2011. Ken's work can be seen in public and private settings across the country in pieces whose sizes engage the observer as part of nature, and in others that encapsulate nature for the observer. In 2000, Ken opened his Japantown San Jose studio to the public and created Art Object Gallery, a setting for his work and that of selected artists working in a variety of media. Here, Ken chisels a sculpture of his subject. (Courtesy of Ken Matsumoto.)

RUDOLPH, MONICA, AND ROSEMARIE DELSON, 1970s. The Delson family moved to 633 Palm Haven Avenue some 50 years after author-poet Edith Daley had the home built. Young Rudolph, atop father Martin's shoulders, grew up in the residence and may have absorbed its literary history, as he published his first novel, *Maynard & Jennica*, in 2007. (Courtesy of Martin and Rosemarie Delson.)

RESTORED PILLAR AT THE PLAZA, 2004. On a warm August evening in 2004, the community came out to dedicate the newly restored original pillars, or electroliers, in Palm Haven. They had been dark for decades, and everyone was thrilled to see the new evening lanterns bringing a part of history back to life. (Courtesy of Michael Borbely.)

ON-LOCATION SHOOTING, 2004. Before Mike Rowe was pitching Fords, he and partner Malou hosted a weekly Bay Area television show, *Mike and Malou*. On this occasion, they hosted the show from Palm Haven, riding in a horse and carriage. With Palm Haven being a visual as well as historical landmark, professional and amateur photographers, artists, and video producers are regular visitors. (Courtesy of Michael Borbely.)

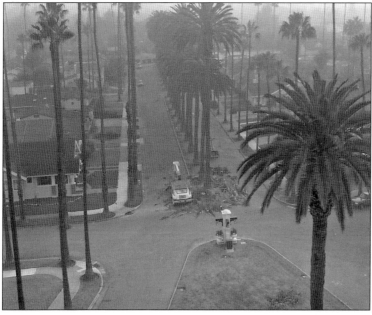

LOOKING DOWN AT TIP OF PLAZA, 2005. Occasionally, the palm trees need trimming, but the process requires a very large crane that can extend to over 100 feet high so crews can reach the crowns of the century-old trees. Every original tree in Palm Haven has been identified, measured, and catalogued to qualify for status as a San Jose Heritage Tree. (Courtesy of Michael Borbely.)

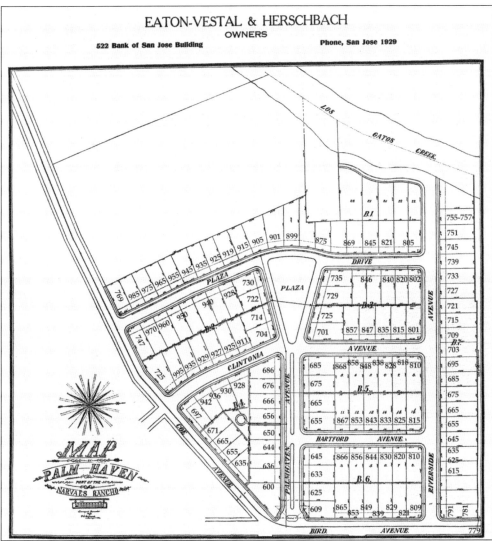

MAP OF PALM HAVEN, 1913. This original sales map has been modified to include the addresses of homes close to where they are located today. Some of the lots have been resubdivided over the years, and actual property lines may vary. In particular, Riverside Avenue (now Riverside Drive) has been reconfigured where it reaches the Los Gatos Creek. For more on the homes of Palm Haven and their history, visit the home search page at www.palmhaven.info. The website also includes an address index to this book. (Courtesy of Michael Borbely.)

DISCOVER THOUSANDS OF LOCAL HISTORY BOOKS
FEATURING MILLIONS OF VINTAGE IMAGES

Arcadia Publishing, the leading local history publisher in the United States, is committed to making history accessible and meaningful through publishing books that celebrate and preserve the heritage of America's people and places.

Find more books like this at
www.arcadiapublishing.com

Search for your hometown history, your old stomping grounds, and even your favorite sports team.

Consistent with our mission to preserve history on a local level, this book was printed in South Carolina on American-made paper and manufactured entirely in the United States. Products carrying the accredited Forest Stewardship Council (FSC) label are printed on 100 percent FSC-certified paper.

MADE IN THE
 USA